IMAGES
of America

MECHANICVILLE

D1500503

ON THE COVER: The corner of Park and Central Avenues had been the hub of Mechanicville for more than a century when this photograph was taken in 1964. The Vogue was a leading clothier, and Waller Drugs dispensed pharmaceuticals and information, functioning as the city's Western Union office and keeping residents in touch with the outside world. This was especially true in the middle of the 20th century, when so many local sons and daughters were serving in distant lands in the armed forces. (Courtesy of the author's collection.)

IMAGES
of America

MECHANICVILLE

Paul Loatman Jr.

ARCADIA
PUBLISHING

Copyright © 2013 by Paul Loatman Jr.
ISBN 978-0-7385-9919-9

Published by Arcadia Publishing
Charleston, South Carolina

Printed in the United States of America

Library of Congress Control Number: 2012953036

For all general information, please contact Arcadia Publishing:
Telephone 843-853-2070
Fax 843-853-0044
E-mail sales@arcadiapublishing.com
For customer service and orders:
Toll-Free 1-888-313-2665

Visit us on the Internet at www.arcadiapublishing.com

*To the people of Mechanicville, whose saga keeps me
endlessly fascinated and wanting to learn more*

CONTENTS

ACKNOWLEDGMENTS

Barbara Michele DeVito aroused my interest in Mechanicville's history in 1962 by relating the saga of her family's 1916 migration from Southern Italy to America and their experiences here. She possessed a memory and a gift for narrative that were truly Homeric. I continued my conversation with my mother-in-law for the next half century until she passed away in 2011 at the age of 101, lucid to the last.

Prof. Francis Curren, SJ, of Fordham University, encouraged my early research on Mechanicville, and Prof. Ivan Steen of the University at Albany supervised my doctoral dissertation, stimulating my interest in local history when the field had little endorsement from academic historians. My predecessors as city historian—John Maloney, whose family donated his invaluable photograph collection to the local library, and Harold Sheehan—were generous with their time, resources, and encouragement, as was Joseph Ianniello.

Many people provided me with valuable background information, especially Saverio Carabis, Anthony Cocozzo, John Caruso, Margaret Delucia, Stephen Dennis, Anthony Luciano, William Sheehan, Christopher Sgambati, Anthony Sylvester, and Robert Tassi. Technical advice was provided by Aaron and Francis Ambrosino. John Caruso, Joseph Micklas, James Salmon, Anthony Sylvester, Joseph Waldron, and Sharon Zappola granted permission to reproduce images from their collections.

The entire staff of the Mechanicville Library was most helpful in giving me access to the photographs donated to its collection by local citizens. Librarian Laura Fisher provided technical assistance, moral support, and generously shared her time, her office, and her expertise. Without her help, this book would not have been possible. Caitrin Cunningham of Arcadia Publishing guided me through the publication process with a steady hand. My wife, Barbara, has shown endless patience with my fascination with local history and the sacrifices she has had to make on its behalf.

More than half of the images used are from the author's collection. Unless otherwise noted, the remainder are from the Mechanicville District Public Library (MDPL).

INTRODUCTION

In 1764, French and Indian War veterans settled New York's northern frontier, among them, four families of Connecticut Congregationalists who occupied the south shore of the Tenendehowa Creek near where it empties into the Hudson River from the west. Harnessing the stream, they created a millrace that powered gristmills and sawmills, and, by the early 1800s, the Fairbanks and Bullen woolen factory downstream. From such beginnings, a classic mill town emerged in the early 1800s.

Soon, the expanding settlement warranted its own post office. How Mechanicville earned its name in 1815 has been the subject of conjecture. Contrary to legend, it had nothing to do with railroads, since Mechanicville was established 20 years before their "invention." More plausible are inferences drawn from an 1887 letter to the editor of the *Mechanicville Mercury* written by a former resident. She recalled witnessing in her youth the contempt wealthy slaveholders displayed toward "lowly mechanics" settled along the Tenendehowa on the "Devil's Half-Acre," a term a local historian still regarded as disrespectful in 1902. Ignoring the insult, these spunky residents embraced a label intended as a slur on their lack of social standing.

In the 1830s, Mechanicville seemed destined to become the center of a new industry. Entrepreneurs Joll Farnham and Jehu Hatfield unlocked the secret formula of French friction matches known as "loco-focos." However, a faulty patent blasted their hopes of cornering the market on an invaluable product. Thomas Terry later merchandised the product locally, earning enough to raise two sons who became lawyers elected to the New York State Legislature. Mechanicville earned some unwanted attention by importing the cholera epidemic from Canada in 1832 aboard a southbound packet on the Champlain Canal that ran through Mechanicville.

The community emerged as a commercial center when the Saratoga & Rensselaer Railway reached Mechanicville in 1835, spurring growth leading to the incorporation of the hamlet as a village in 1859. Two years later, national attention focused on a native son, Col. Elmer E. Ellsworth, who became the Union's first hero in the Civil War. The shocking assassination of the former Lincoln law clerk on May 24, 1861, spurred thousands of Union enlistments. Ordering Ellsworth's remains to lie in state in the White House, Lincoln wrote Ellsworth's parents: "In the untimely loss of your noble son, our affliction here, is scarcely less than your own." The monument marking Ellsworth's gravesite in Mechanicville became the site for annual memorials for generations of Civil War veterans.

Later developments solidified Mechanicville's transformation into an industrial mill town. The Boston, Hoosac Tunnel & Western Railway arrived in 1878, providing access to markets in New England, the Mohawk Valley, and the Midwest. In 1885, the Hudson River Water Power and Paper Company completed construction of a hydropower dam on the Hudson River. Some original investors more interested in hydroelectric development than papermaking erected a second dam a mile south of the original site in 1897. Enlisting the expertise of Charles Steinmetz, Thomas Edison's scientific partner at General Electric, experiments leading to innovations in the

electrical industry were conducted here. Meanwhile, northeastern rail consolidation increased the importance of the local rail yards. The Delaware & Hudson and Boston & Maine car-repair shops and transfer docks employed more than 1,000 railroaders in the first two decades of the 1900s. By the time America entered World War I in 1917, the Mechanicville yards had become the third-largest freight transfer hub in the nation.

Similarly, the West Virginia Pulp and Paper Company's purchase of the local mill in 1904 led to a program of expansion that ultimately created the largest book-paper mill in the world. Additionally, a vibrant textile industry, extensive brickyard operations, and sash and blind manufacturing helped Mechanicville become a thriving mill town of nearly 10,000 residents by the 1920s. This rapid growth led the village to seek incorporation as a city. The state legislature approved a municipal charter in 1915, making Mechanicville the smallest city in New York State, at less than one square mile.

In 1917, state senator George Whitney introduced legislation annexing the outlying rail yards, brickyards, and paper mill property, which were functionally already part of the city. The municipality sought to tax corporations already benefitting from fire and police protection, as well as its sewer and water systems. Residents had come to believe that the railroads and paper mill had been getting a free ride for too long. But, without warning, Senator Whitney withdrew his annexation bill, leading to widespread public outrage. Farrington Mead, who had editorialized on behalf of business interests for decades, blasted Whitney for surrendering to corporate pressure.

This would not be the last time municipal expansion failed. Residents of Pruyn Hill petitioned for annexation during World War II, but Gov. Thomas E. Dewey vetoed the move. In 1969, a New York State Supreme Court judge upheld the protest of a lone Halfmoon taxpayer who opposed fellow property owners who had sought annexation. Reportedly, this is the only instance in New York State history when a court order blocked municipal annexation.

By 1970, northeastern railroads were in decline, brick making had migrated elsewhere, and the Korell Corporation operated the last textile mill in a community that had once been home to four such facilities. Then, in 1971, Westvaco ended its operations here. A decade earlier, the papermaker had employed more than 1,300 hourly and professional employees. In short order, Mechanicville was suddenly transformed into a postindustrial city. What had once been a thriving self-contained mill town whose industries traded in national and world markets was transformed into a bedroom community for residents commuting to work in Albany and Schenectady. Emphasizing the change in fortune, the local superintendent of schools noted in 1976 that the public school system had suddenly become the district's largest employer. By 2000, the population had been cut in half from its 1925 peak. While it still serves as the urban core for people living outside the municipality, consideration has been given to the idea of reverting to village status. Yet, the disadvantages of such a move appear to outweigh its benefits.

Originally settled by Dutch and New England farmers, industrial expansion later attracted immigrants from Lithuania, Ireland, and Italy. Each group established an ethnic enclave in Mechanicville characterized by a close-knit, family-centered way of life, giving the city a unique flavor of personal intimacy that is immediately apparent to visitors. Christmas, Thanksgiving, and Easter are important celebrations here, as they are throughout the nation. But Mechanicville's friends, neighbors, and extended families began celebrating a uniquely local creation, Family Day, in July 1976, and it has become a tradition. For a few days each year, the city's streets are once again crowded with thousands of visitors who renew friendships and celebrate their roots while recalling the days when Mechanicville was a thriving mill town.

One

"BEGINNING AT LYMAN DWIGHT'S CULVERT"

Mechanicville was considered a village long before it achieved that legal status from the Court of General Sessions of Saratoga County in 1859. Census takers had listed the Village of Mechanicville on their rolls for years, on 200 acres "beginning at Lyman Dwight's culvert." And while the opening of a post office in 1815 implied legal incorporation in the public mind, the hamlet occupied sections of the towns of Halfmoon and Stillwater, and convincing both entities to relinquish control of their respective domains proved difficult.

In the end, business interests dictated the wisdom of such a move. Lewis E. Smith, Lyman Dwight, Daniel LaDow, and others who had valuable investments in the textile and sash and blind industries took the lead in incorporating the village to promote the formation of a volunteer fire department. Yet, despite the fact that the village's charter permitted such a step, the effort to organize volunteers languished for years.

Although the village board purchased a hand-pumper in 1875, it was not until 1884 that the formation of a second fire company permitted the organization of the long-awaited Mechanicville Fire Department. By then, editor Farrington L. Mead had begun his 40-year crusade employing the pages of his *Mechanicville Mercury* [the *Saturday Mercury* as of 1894] to prod, cajole, and threaten businessmen and politicians to do everything in their power to make Mechanicville an industrial and commercial leader, even envisioning the incorporation of surrounding townships under its aegis. Before putting his pen aside in May 1920, Mead witnessed the village's population grow almost tenfold, and saw it receive a city charter and initiate plans to annex adjacent business properties. In the end, these ambitious plans, fostered by the representatives of the 977 residents of those 200 acres on the Hudson River in 1859, had nearly been fulfilled.

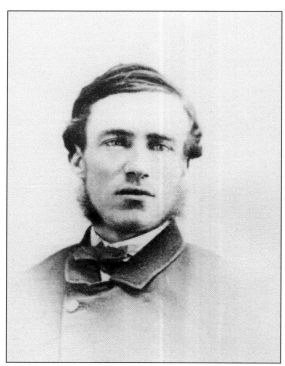

Lyman Dwight, the second president of the village board, in 1862, was a prime mover in petitioning the court of general sessions to incorporate Mechanicville as a village. He later sold two large parcels of land crucial to the development of the Hudson River Water Power and Paper Company. (MDPL.)

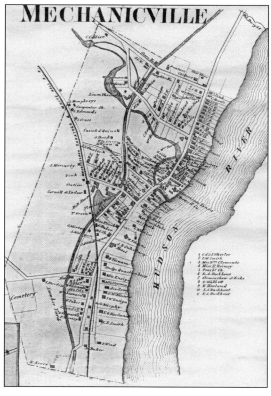

This 1861 map shows Mechanicville's development limited to the area between the Hudson River and the Champlain Canal. To that point, industrial development had been limited to exploiting the power of the Tenedehowa Creek to run the gristmills and sawmills owned by the village's largest business, the American Linen Thread Company.

Lewis Smith operated the American Linen Thread Company from 1850 until 1881, when it was absorbed by a New England competitor. According to the *New York Times,* linen thread had become unmarketable because its inelasticity prevented its use in sewing machines. Linen thread had also been used to make fishing lines and nets. Smith served as village president for eight years in the 1870s. Following the sale of the property to the Ross and Van Schoonhoven firm, the mill was replaced by a large commercial block in the 1890s. (MDPL.)

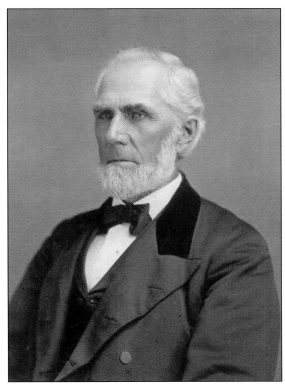

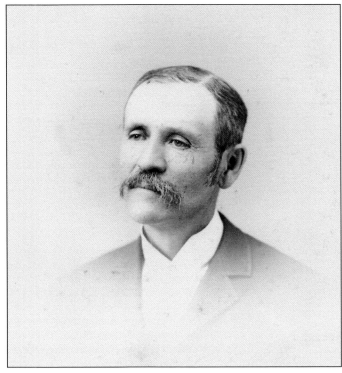

Daniel LaDow, the co-owner of the Barnes and LaDow Sash and Blind Company, was elected village president in 1883 and organized the D.E. LaDow Hose Company in 1884, which eventually led to the creation of the Mechanicville Fire Department. An 1875 ordinance stipulated that a fire department required the existence of two hose companies. Fire losses sustained by local businesses created pressure to protect the community. Volunteer fire companies have been a vital player in local affairs ever since. (MDPL.)

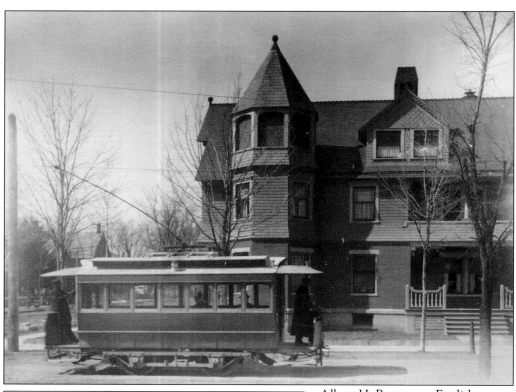

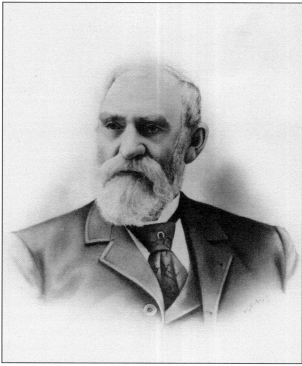

Albert H. Barnes, an English immigrant whose father had escaped from debtors' prison, worked as a hired hand on a local farm. A chance encounter with Daniel LaDow's daughter led to marriage, making Barnes a partner in the sash and blinds business with his father-in-law. His home on Second Street (above) looks much the same today as it did when it was built in the 1890s, except for the removal of the steps on the side porch.

William C. Tallmadge, who served as justice of the peace in 1878 and village president in 1892, was a power broker in Republican Party politics, a real estate developer, and a municipal benefactor. In 1895, he donated 10 acres of his former horse-racing park to the village. It remains one of the community's prime assets. (MDPL.)

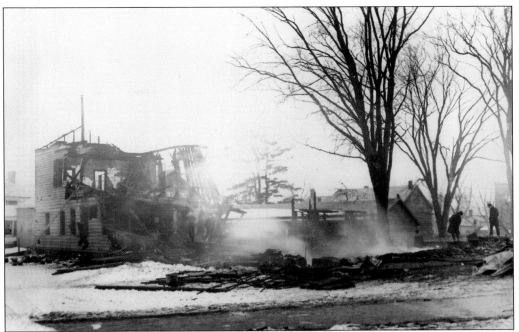

In February 1898, the Hotel Tallmadge on South Main Street was destroyed by fire. Built in 1797 and known variously as Burnap's and the Saratoga Hotel, it housed workmen who built the Champlain Canal in the 1820s and entertained prominent figures attending the funeral of Col. Elmer E. Ellsworth in May 1861.

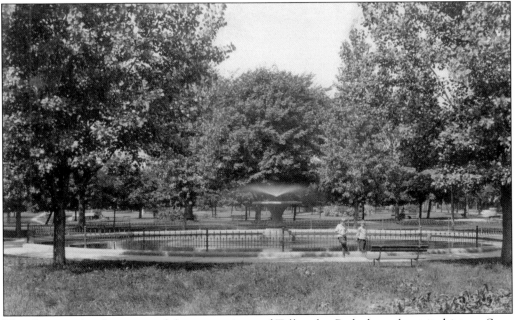

This fountain has been one of the centerpieces of Tallmadge Park throughout its history. Seen here around 1900, the fence has since been removed. In recent years, it has become the site for annual prom photographs as well as outdoor weddings. (Courtesy of Joseph Waldron.)

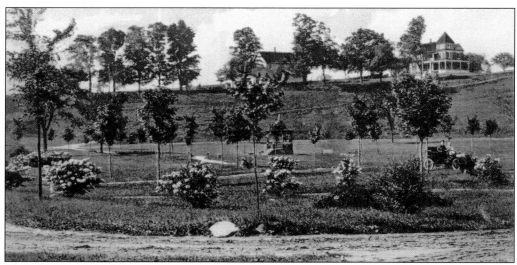

This photograph looks west through Tallmadge Park toward Pruyn Hill in the early 1900s. Of note are the bandstand and the automobile. This bandstand was later replaced by a larger structure, and, although the outer roadway circling the park permits automobile traffic today, the inner pathways are restricted to walking. It is likely that the vehicle seen here was so rare that its novelty had not yet provoked disapproval.

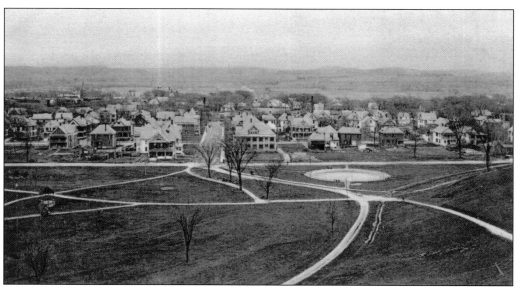

This overview of Mechanicville from around 1900 reveals little development on Third Street or Park Place. The absence of trees is noteworthy as well. In the 1880s, the park had been used by William C. Tallmadge as a racecourse and a baseball field, which were surrounded by a fence so that admission could be charged.

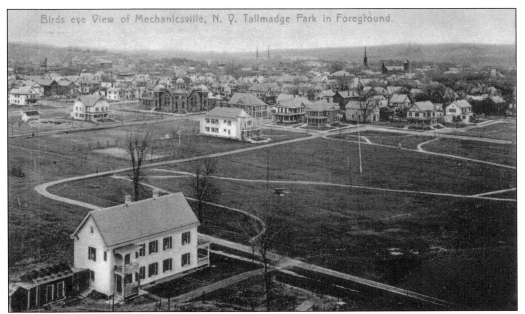

This view from Pruyn Hill overlooking the northern end of Tallmadge Park shows no development beyond Fourth Street, although William C. Tallmadge had already subdivided the area outside of the park into building lots. Restrictive covenants dictating setbacks for houses built on Park Avenue and Park Place are still enforced in property deeds. The cannon in the center of the park was later moved to the other end. A recent examination by an ordnance historian determined that it is an Army cannon built in Richmond, Virginia, about 1830.

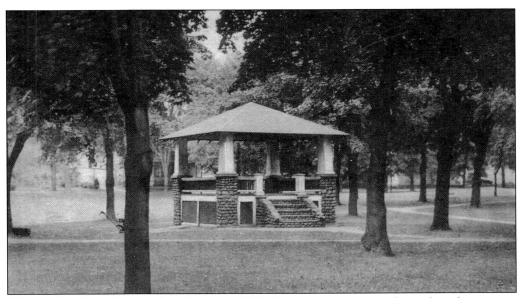

The new bandstand was built in the early 1900s. In the ensuing years, the park took on a new character, as its open spaces became dominated by the maple trees typical of this region. The bandstand has served as a focal point for decades, hosting public concerts and events such as the annual Family Day, and, recently, the August 15th Feast of the Assumption celebrations.

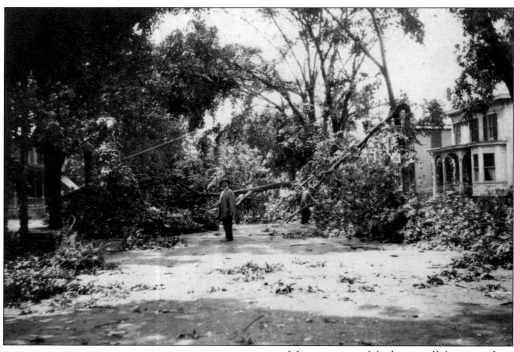

H. B. MACE,

Furnishing

Undertaker,

DEALER IN

FURNITURE

Of Every Description.

The Largest Ware-rooms in this section
of Saratoga county.

Park Avenue,

MECHANICVILLE, N. Y.

Don't forget to go to

SHOOK'S

RESTAURANT

For a Dozen

Blue Points on the Half Shell.
Little Necks on the Half Shell.

The only place in town for Shell Oysters

PARK AVENUE,

MECHANICVILLE, N. Y.

LADIES' GENERAL COMMITTEE:

Mrs. A. L. Strang, Chairman.

Mrs. F. S. Clute, Mrs. E. J. Bush, Mrs. G. W. Clarke, Mrs. Fred Packer.

S. J. MOORE,

DEALER IN

Boots, Shoes,

AND

Rubber Goods,

N. Main Street, Head of River Street,

MECHANICVILLE, N. Y.

WILD BEEF

has not got the rich flavor of the "farm"
grown cattle. And it is not so tender.
We make it a point to get home raised Beef,
Lamb and Pork, and that is the reason our
meats are so tender, juicy and toothsome.
Our poultry is fresh killed and dry picked.
The chickens we sell will taste delicious.
Prices reasonable.

W. LEE,

Park Avenue, *Mechanicville.*

Many trees on Mechanicville's west side and in Tallmadge Park were knocked down by a tornado in 1916 (above). The twister swept through Hudson View Cemetery and down across the park, taking everyone by surprise. Local editor Farington Mead remarked that because Mechanicville had not witnessed a violent weather outbreak in a long time, everyone assumed that such a thing could not happen. Similar feelings marked the reaction to the much more devastating tornadoes that hit the city in 1998. Despite widespread property damage, no lives were lost in either instance.

This 1898 advertisement in a fundraising bulletin warned people against purchasing "wild beef" raised on the Great Plains and shipped east on the railroad. The plea to eat locally raised beef anticipated the local food movement of the early 2000s by a century.

The Grand Central Hotel was one of a number of hotels at the intersection of the village's trolley and railroad lines. It hosted traveling businessmen, tourists, and vaudeville acts playing the Crosby Opera House, adjacent to the hotel.

Hotel Hawley (below) was on the west side of the Delaware & Hudson tracks, across from the Grand Central Hotel on Park Avenue. Lack of development on the west side led some people to question the Baptists' decision to relocate from William Street to the remoteness of Fourth Street and Park Avenue in 1899.

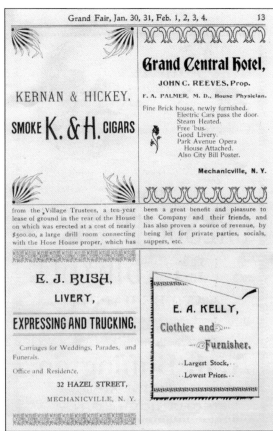

Grand Fair, Jan. 30, 31, Feb. 1, 2, 3, 4. 13

KERNAN & HICKEY.

SMOKE K. & H. CIGARS

Grand Central Hotel,

JOHN C. REEVES, Prop.

F. A. PALMER, M. D., House Physician.

Fine Brick house, newly furnished.
Electric Cars pass the door.
Steam Heated.
Free 'bus.
Good Livery.
Park Avenue Opera
House Attached.
Also City Bill Poster.

Mechanicville, N. Y.

from the Village Trustees, a ten-year lease of ground in the rear of the House on which was erected at a cost of nearly $500.00, a large drill room connecting with the Hose House proper, which has

been a great benefit and pleasure to the Company and their friends, and has also proven a source of revenue, by being let for private parties, socials, suppers, etc.

E. J. BUSH,

LIVERY,

EXPRESSING AND TRUCKING.

Carriages for Weddings, Parades, and Funerals.

Office and Residence,

32 HAZEL STREET,

MECHANICVILLE, N. Y.

E. A. KELLY,

Clothier and

Furnisher,

..Largest Stock,..
..Lowest Prices...

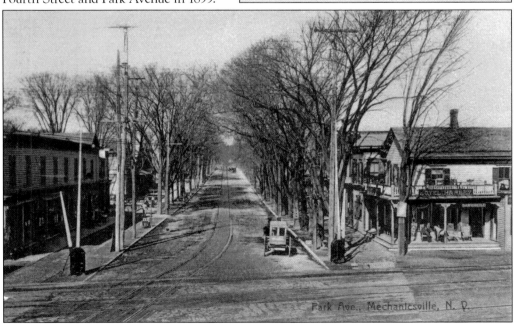

Park Ave., Mechanicville, N. Y.

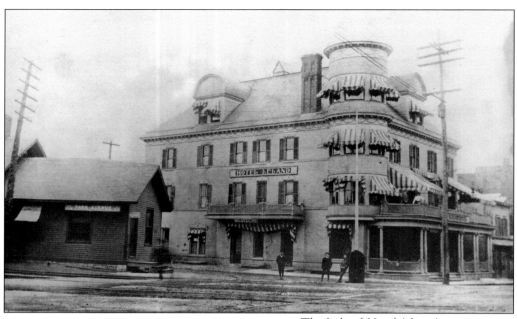

The Leland Hotel (above) was on the corner of Park Avenue and Railroad Street, across from the Grand Central Hotel. Built in the 1890s, its reading room and bar on the first floor hosted many receptions. The Leland outlasted all of its competitors, and was still operating in the 1950s as the Estelle Rita Hotel. The original blueprints are on file at the Mechanicville Public Library.

14 E. H. Strang' Hose Company,

....PRICES....

Juvenile, . . . $ 25.⁰⁰

Full Size, . . 35.⁰⁰

Chainless, . . 60.⁰⁰

A Word to the Wise is Sufficient.

...RIDE A...

CRESCENT BICYCLE

AND BE HAPPY!

Manufactured and Guaranteed by the largest firm in the business.

Samples on Exhibition at the store of

A. J. Buffington,

12 and 14 Park Avenue,

MECHANICVILLE, N.Y.

Bicycling became a national craze in the late 1800s, and the results of interurban competitions were reported in the *New York Times* and other papers. The largest advertisements in the Strang 1898 fundraising bulletin featured bicycles.

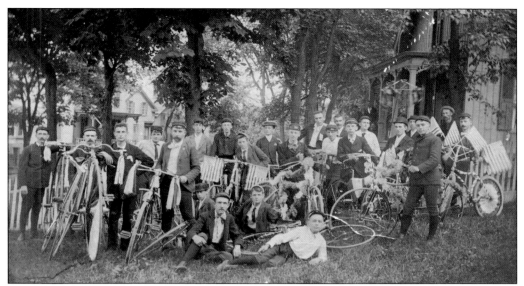

Wheelmen, as bicyclers were called at the time, created demand for paved macadam highways, unwittingly preparing the way for the coming of the automobile. This group includes, from left to right, (seated) unidentified, R.V. Tompkins, Sanky Van Emberg, and Bobby Moore; (standing) Dell Orcutt, Newt Bryan, Rennie Smith, George Tilly, Bert Whitney, Len Baker, Fred Clute, Chick Rogers, unidentified, Jay LaDow, Fred Medway, George Doughty, Bert Walrath, Irv VanZandt, Will Benham, Frank Longstaff, unidentified, Allie Barnes, Fred Partridge, and Art Strang.

E.H. Strang, the village president in 1892, organized the E.H. Strang Hose Company in 1894, in response to concerns from west side residents that their property was unprotected daily, when Delaware & Hudson trains cut them off from the rest of the village. (MDPL.)

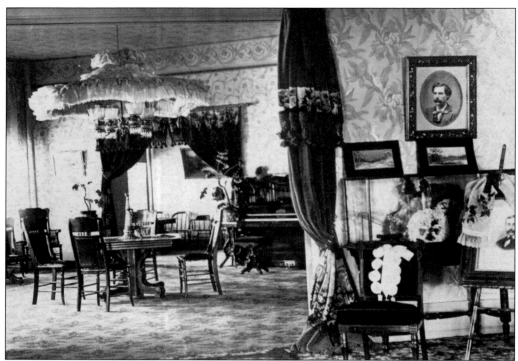

The Strang Hose Company's headquarters were located on North Third Street. Like all volunteer units, Strang's provided a valuable social outlet for men, with its rooms above the apparatus garage used for social gatherings. The building was used as a private residence for a time before being torn down in 2002.

This 1959 photograph shows the Delaware & Hudson passenger station in the foreground, with the Strang textile mill, partially obscured, in the left background. The mill building, out of use since the early 1940s, burned down in 1966. (Courtesy of John Caruso.)

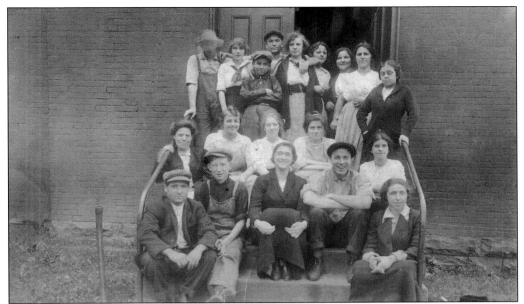

E.H. Strang opened a textile mill at the foot of Viall Avenue, adjacent to the Boston & Maine tracks. Employees in 1904 benefited from a profit-sharing program that was unique for its time. Labor disturbances were regularly recorded in the local newspaper, but no reports of worker unrest at the Strang mill ever appeared in the *Saturday Mercury*. (MDPL.)

C.W. Orcutt is seen here at a Strang outing to King's Point, on the Hudson River, in 1899. The Strang family was active in the local community for the better part of a century and widely admired for their civic-mindedness.

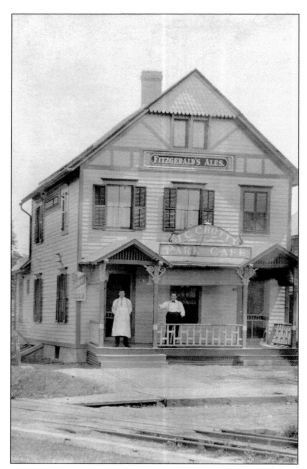

J.C. Crotty's Park Café, featuring Dobler Beer and Fitzgerald Ale, aroused editor Farrington Mead's concerns that "bucket shops" catered to the many unattached men attracted by the railroads. Along with fellow Methodists, Mead waged a constant war against "liquor interests," which he believed dominated local politics.

The Champlain Canal (below) bifurcated Mechanicville, focusing the community's center at the Park Avenue lift bridge, one of the first pneumatic canal bridges in the state. The large brick Mead Building, in the right background, housed the weekly newspaper and the local post office. It was torn down in the late 1970s.

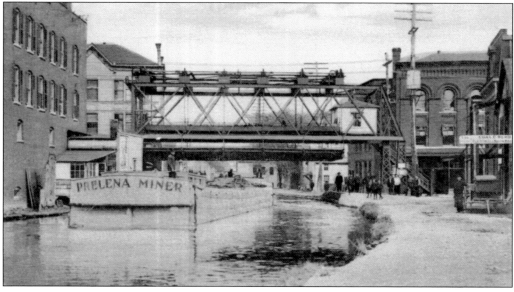

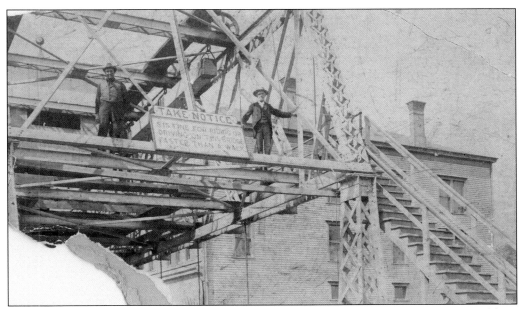

The fine for riding or driving faster than a walk across the Park Avenue lift bridge was seldom, if ever, enforced. Farrington Mead, who editorialized on virtually everything that happened in Mechanicville between 1884 and 1920, never raised the issue. (MDPL.)

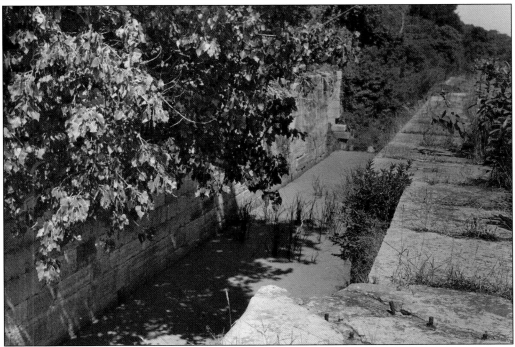

The old canal south of the city, seen here in 1966, was owned by the municipality until it was transferred to the town of Halfmoon, in which it lies. The original wooden locks were replaced by stone that was quarried at Kingsbury, near Glens Falls, and sledged here in the winter of 1826–1827. (MDPL.)

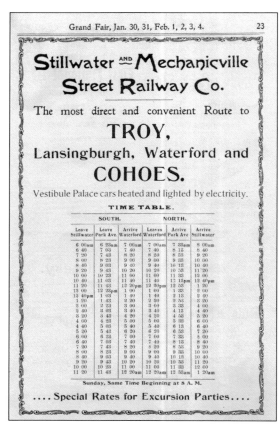

Stillwater ᴬᴺᴰ Mechanicville Street Railway Co.

The most direct and convenient Route to

TROY,

Lansingburgh, Waterford and

COHOES.

Vestibule Palace cars heated and lighted by electricity.

TIME TABLE.

SOUTH.			NORTH.		
Leave Stillwater	Leave Park Ave.	Arrive Waterford	Leaves Waterford	Arrive Park Ave	Arrive Stillwater
6 00am	6 23am	7 00am	7 00am	7 33am	8 00am
6 40	7 03	7 40	7 40	8 13	8 40
7 20	7 43	8 20	8 20	8 53	9 20
8 00	8 23	9 00	9 00	9 33	10 00
8 40	9 03	9 40	9 40	10 13	10 40
9 20	9 43	10 20	10 20	10 53	11 20
10 00	10 23	11 00	11 00	11 33	12 00
10 40	11 03	11 40	11 40	12 13pm	12 40pm
11 20	11 43	12 20pm	12 20pm	12 53	1 20
12 00	12 23pm	1 00	1 00	1 35	2 00
12 40pm	1 03	1 40	1 40	2 13	2 40
1 20	1 43	2 20	2 20	2 54	3 20
2 00	2 23	3 00	3 00	3 33	4 00
2 40	3 03	3 40	3 40	4 13	4 40
3 20	3 43	4 20	4 20	4 53	5 20
4 00	4 23	5 00	5 00	5 33	6 00
4 40	5 03	5 40	5 40	6 13	6 40
5 20	5 43	6 20	6 20	6 53	7 20
6 00	6 23	7 00	7 00	7 33	8 00
6 40	7 03	7 40	7 40	8 13	8 40
7 20	7 43	8 20	8 20	8 53	9 20
8 00	8 23	9 00	9 00	9 33	10 00
8 40	9 03	9 40	9 40	10 13	10 40
9 20	9 43	10 20	10 20	10 53	11 20
10 00	10 23	11 00	11 00	11 33	12 00
11 20	11 43	12 20am	12 20am	12 53am	1 20am

Sunday, Same Time Beginning at 8 A. M.

.... Special Rates for Excursion Parties....

This 1898 trolley schedule reveals that residents had daily access to points south, a form of public transportation long since missing from the community. After 1900, the Stillwater-Mechanicville line was integrated into the larger Hudson Valley Railway interurban system, which made connections northward to Warrensburg and south to Hudson, spanning a distance of almost 100 miles.

The last trip of the horse-drawn trolley cars connecting Mechanicville and Stillwater, which began in 1882, is seen below 13 years later leaving the Delaware & Hudson passenger station in Mechanicville. Farrington Mead reported on December 28, 1895, that electric cars had begun running as of Christmas Day. (Courtesy of Anthony Sylvester.)

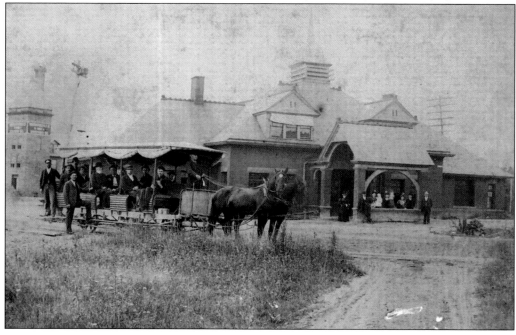

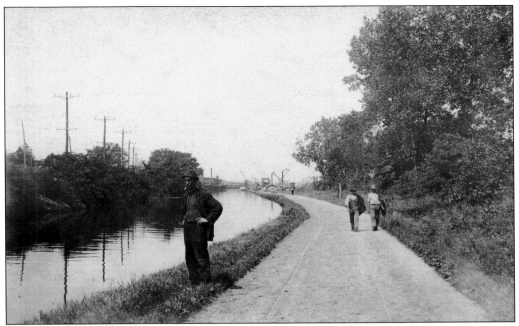

The Champlain Canal towpath was not restricted to mules. Pedestrians traversed it to get back and forth to the paper mill, seen in the background. This portion of the canal was purposely not drained during the winter, to allow for community ice-skating in cold snaps. A special flag hoisted from the Park Avenue lift bridge signaled when the ice was safe for skaters.

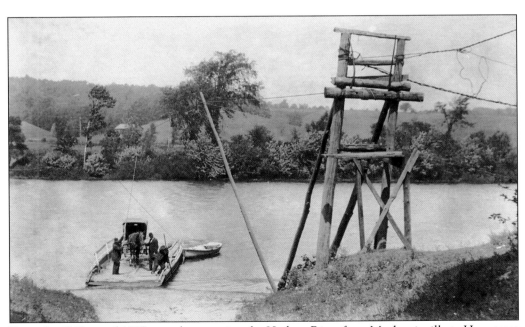

From the 1860s until 1888, travelers crossing the Hudson River from Mechanicville to Hemstreet Park had access to an irregular ferry service. The ferryman was beckoned by the sounding of a horn during the day and the shaking of the guide wire at night.

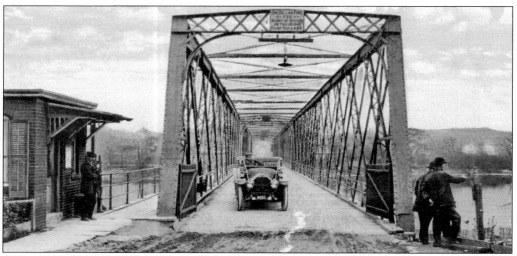

Ferry service ended on September 8, 1888, when local investors opened a toll bridge. The following summer, the village board banned nude bathing in the river, to avoid embarrassing female travelers. At state senator George Whitney's urging, the bridge became toll-free in 1913. The span was replaced with a new structure erected farther north in 1950.

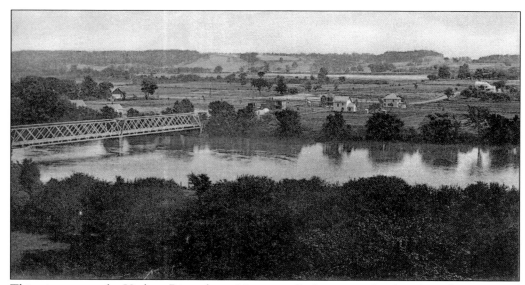

This view across the Hudson River shows Hemstreet Park as an undeveloped rural area around 1900. Much of the land in the upper left was owned by the paper mill, which built a golf course there in 1909. The toll bridge seen here was about 500 feet south of the current structure, which replaced it.

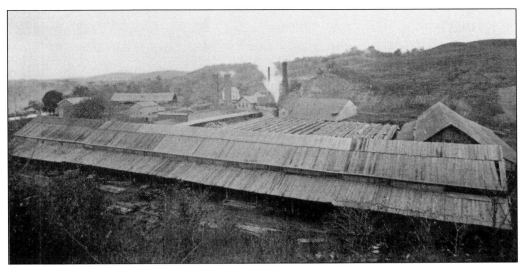

Brick making developed as an offshoot of the paper industry. When the Hudson River Water Power and Paper Company began building its facilities in 1882, it discovered large deposits of clay ideal for brick making. In the next two decades, the Best, Duffney, Champlain, Mechanicville, and Mohawk companies developed a vigorous brick industry, attracting large numbers of Italian immigrants. Local yards supplied developers in Boston, and the New York City viaduct system was built with Mechanicville brick.

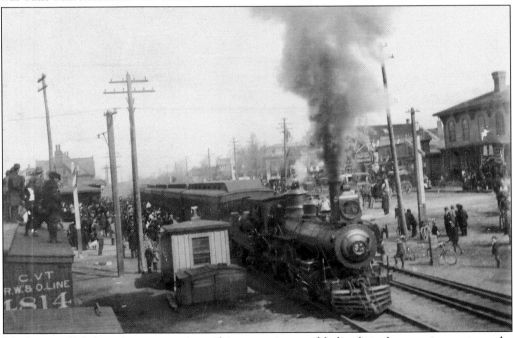

Mechanicville's location at a major rail intersection enabled political campaigners to make whistle-stop speeches that attracted large crowds, including Teddy Roosevelt during his 1898 gubernatorial campaign. Editor Farrington Mead was unimpressed by the future president, writing, "The Rough Rider left a poor impression in Mechanicville. The consuming vanity of the man drives away support."

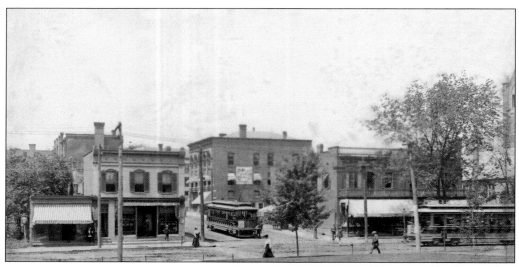

Above, one block east of the lift bridge, a conductor holds his car to permit an oncoming trolley to turn up Park Avenue or continue southward. The Manufacturers National Bank, built on the southwest corner of Main Street in 1884, was later replaced by a more prominent building, which is now a Key Bank.

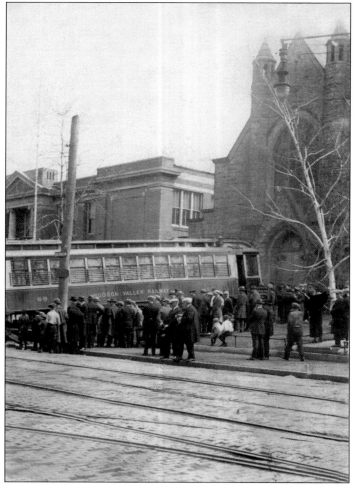

In local parlance, a trolley "got religion" when it failed to make the left turn at Park Avenue and North Main Street and came within a foot or two from joining the Episcopal congregation. Parishioners remarked at how fortunate they were to have relocated their new church in 1897 farther back from the street than the original church. (Courtesy of Joseph Waldron.)

Two

Sid Fort's
Victorian America

Sidney Fort was born in 1878 to Cornelius and Margaret Fort, also the parents of Ida and Florence Fort, who established the C.M. Fort Store in Mechanicville in 1875. While it initially focused on selling canned goods, the firm's stock grew to include shoes, crockery, seeds, jewelry, and glassware, with regular advertisements in the weekly *Mechanicville Mercury*. By 1930, "home furnishings" had become the primary line of business according to an advertisement in the city directory. The store had moved to a modern building grafted onto a Revolutionary War–era cobblestone house once owned by Dr. John Cuerdon, a British surgeon who settled here after accompanying Burgoyne's fateful trek to nearby Saratoga in 1777. C.M Fort and Son once again adapted to changing markets by specializing in the sale of "paints, wallpaper, and electrical appliances," as advertised in the 1949 city directory.

Sid Fort joined the firm in 1901, when his father's declining health and "the need to add some push" to the business led him to announce the formation of C.M. Fort and Son, as noted in the firemen's convention souvenir book in 1902. Before taking control of the store, the younger Fort had become a devotee of glass-plate photography, refining techniques while shooting his family and friends in informal settings. It is unlikely that Fort intended to record everyday life for posterity when he convinced his subjects to pose for him between 1897 and 1900. However, his familiarity with them permitted him to capture intimate glimpses of social life in a small community, which are rarely available to local historians.

Judging from the numbering system used to keep track of his prints and their accompanying notations, about half have survived. They provide us with a rich historical resource, offering a unique glimpse into middle-class life in a Victorian community being transformed by the forces of industrialism. His son Sid Jr. served as the Mechanicville postmaster after leaving the family business and selling the family property on North Main Street to the Urban Renewal Agency in 1969 to make space for a church parking lot.

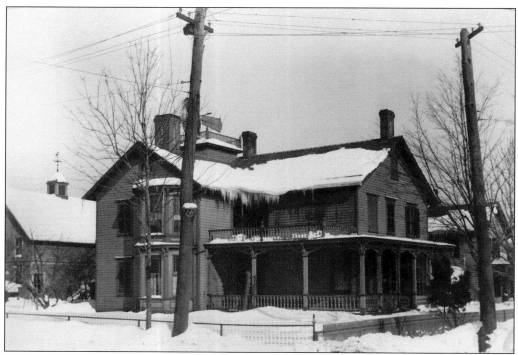

Built in 1896, the Fort home on Hazel Street (now Second Street) was the first to be erected with sewer connections and indoor plumbing. The local newspaper reported that homeowners were greatly reluctant to hook up to the system. However, outbreaks of typhoid and other communicable diseases led the local health board to ban backyard privies, forcing all homeowners to connect to the new system.

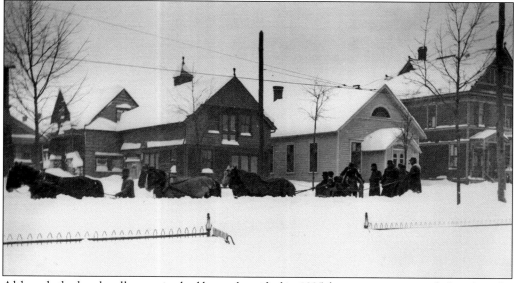

Although the local trolley service had been electrified in 1895, horsepower was needed to clear the tracks on Hazel Street following this major 1898 snowstorm. The two homes in the background were later replaced by two-family structures that still stand today.

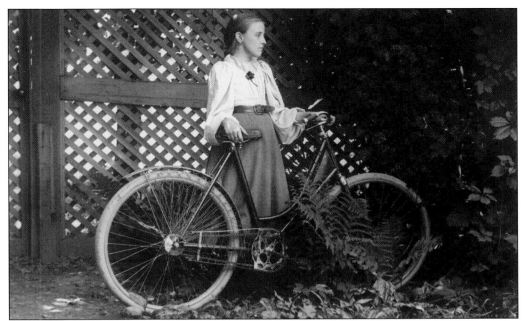

Sid Fort began his photographic career in 1897 by posing his younger sister Florence, age 13, with her "wheel." The newly designed safety bicycle permitted women and girls to engage in vigorous physical activity for the first time. The four-page *Saturday Mercury* regularly carried three or four prominent bicycle advertisements throughout the 1890s and reported the results of interurban bicycle races.

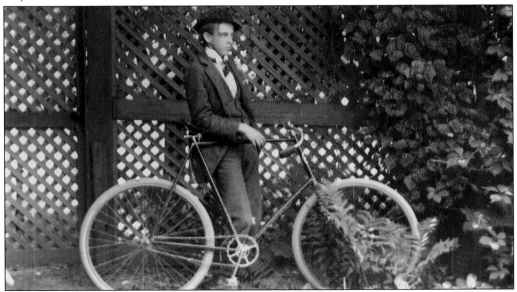

In another early photograph, Sid Fort poses with his bicycle, which notably lacks the fender or chain guard typical of girls' bicycles. Cyclists could purchase a Crescent Juvenile for $25, while more elaborate bicycles cost four or five times that. While Henry Ford is often credited by historians as introducing installment purchasing in 1913, bicycle advertisements regularly offered purchases on a credit plan.

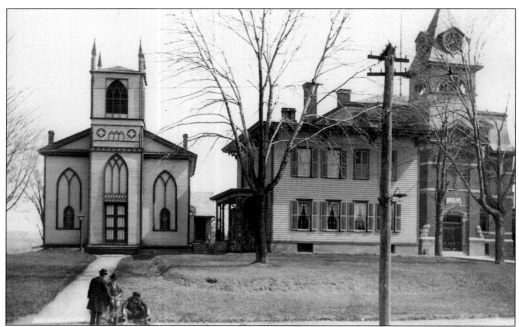

Built originally as a community church open to all in 1830, this wooden structure was consecrated as St. Luke's Episcopal Church in 1832, with the parsonage in the right foreground added later. The Mechanicville school, in the right background, was erected in 1888. An unanticipated bequest from Dr. Newton Ballou in 1895 offered to build a new Indiana limestone church with the stipulation that the project had to be completed within three years.

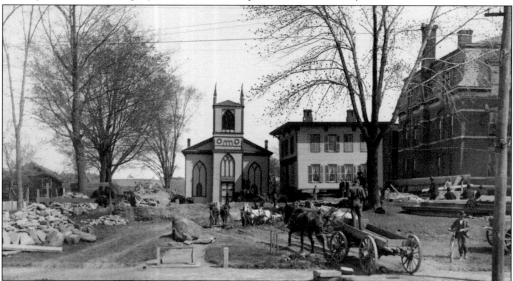

The church and rectory were removed to make way for the new church in 1897, complying with Dr. Ballou's requirement that once the new building was erected, other structures had to be removed. The original church and rectory were dismantled and sold as scrap lumber. Recently, St. Luke's relocated to the town of Halfmoon, and, since 2004, the church building has served as an arts center.

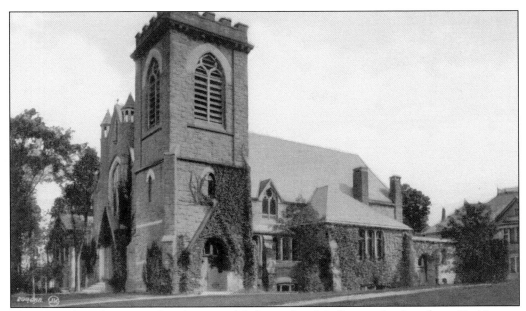

The new Indiana limestone church was modeled on a church in Europe that benefactor Dr. Newton Ballou had seen while traveling there. A later bequest from the descendants of Lyman Dwight led to the installation of six stained-glass windows designed by noted Boston artist Mary Hamilton Frye between 1936 and 1940, dedicated to the memory of Lyman Dwight and his family.

Sid Fort inscribed this photograph, "Frank Woodworth Got Up for the Murder of Officer Montesall," raising a raft of unanswered questions. Such a murder is never referred to in local records, and how and why such a notorious criminal would be allowed to pose for a photograph is unexplained. He is seen outside of the village hall in front of the local lockup, used as a temporary jail at the time. The multiunit building in the background was torn down soon after this photograph was taken in 1898 and replaced by a prominent brick structure that still stands today.

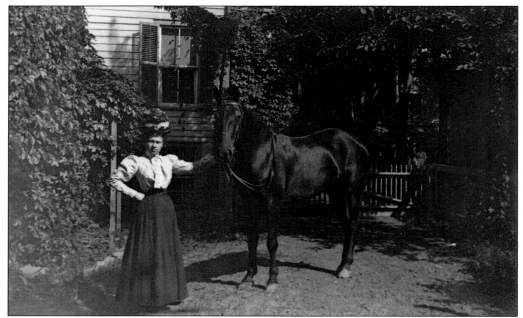

Why Mary Collins posed with Frank Woodworth's horse is also anyone's guess. The Collins family ran a florist shop, which is still in business, next to the local lockup. However, it seems unlikely that Collins could take any credit for capturing Woodworth. The fact that the ever-vigilant editor Farrington Mead fails to mention anything about this event in his weekly columns merely adds to the mystery of why Sid Fort was so fascinated with the case.

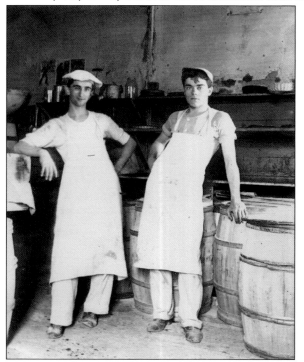

John Barry (left) and Frank Carpenter worked at Carpenter's Bakery in 1898. Their relaxed posture, also seen in other photographs in the Fort collection, indicates familiarity between the photographer and his subjects. Background details may remind modern viewers that Teddy Roosevelt had not yet cajoled Congress into passing the Pure Food and Drug Act. New York State law limited bakers to working no more than 60 hours per week, an act struck down by the Supreme Court as an infringement of bakers' freedom in 1905.

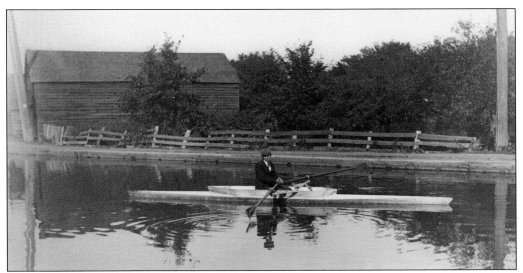

Charlie Elms enjoyed rowing on the Champlain Canal, which bifurcated Mechanicville on a north-south axis when this photograph was taken in 1898, technically making most of the village an island. The original four-foot-deep waterway was relocated into the Hudson River between 1910 and 1912. Besides providing a venue for ice-skating in the winter, the canal was regularly tapped by local firemen to fight fires.

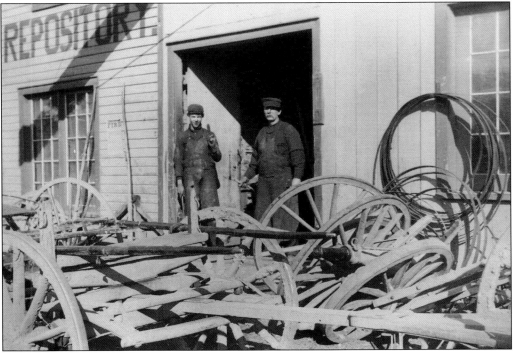

John Hurd (left) and his father, Charles, worked as wheelwrights in 1897 at Joseph Dodd's shop, which advertised the sale of wagons, carriages, and sleighs on the southeast side of the Park Avenue lift bridge. Dodd was an English immigrant who came here in 1849. By 1910, the skills needed to create these products had become outdated with the advent of the automobile.

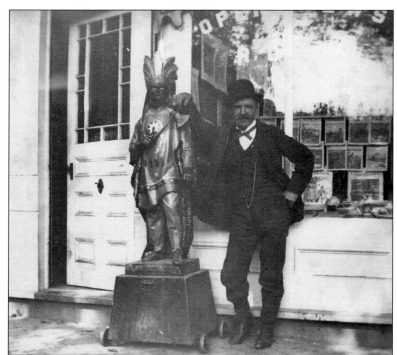

Albert Boucher leans on his cigar store Indian in front of his establishment on North Main Street in 1897, seven years after the battle of Wounded Knee. Boucher appears in a number of Sid Fort's photographs, and the bottoms of his tight-fitting pants suggest that he was a bicyclist like his friend Fort. In the background, copies of *Ladies Home Journal* and *Leslie's Quarterly* are offered for sale.

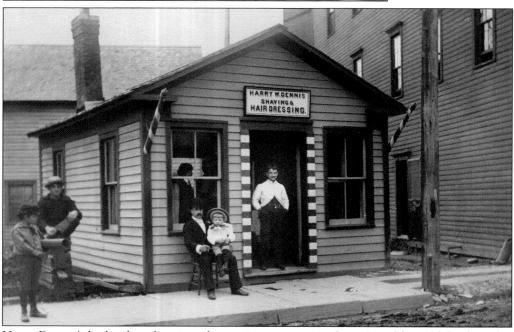

Harry Dennis's barbershop functioned as an intergenerational men's and boys' club when this photograph—one of Sid Fort's earliest prints—was taken in 1897. Note the twin barber poles protruding from the shop, the new sidewalk, and the still-unpaved street. The barber's name does not appear in any census records from that era, and while the 1898 Strang fundraising bulletin lists a number of barbers, Dennis is not among them.

Although Sid Fort did not include the first name of his subject on the back of this photograph, the member of the Collins family freezing ice cream in the back of Hall's Pharmacy on Park Avenue in 1897 was most likely a sibling of Mary Collins, seen in earlier photographs. Currently, the northwest corner of Park and North Central Avenues houses one of the busiest McDonald's restaurants in the capital district.

C.M. Fort prepares to make a delivery by the time-honored method of horse and sleigh. Sled travel was widely employed in the 1890s for both business and personal reasons. Mechanicville's social calendar, as recorded in the local newspaper, included many overnight sleigh rides to Troy and the surrounding communities, which were popular with young couples.

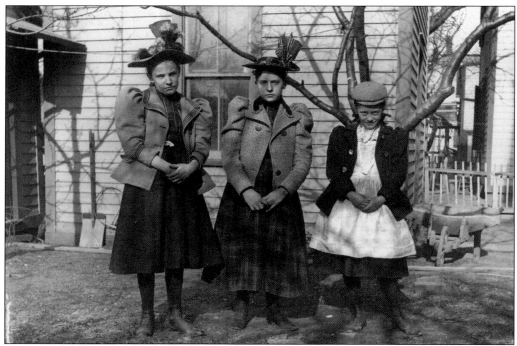

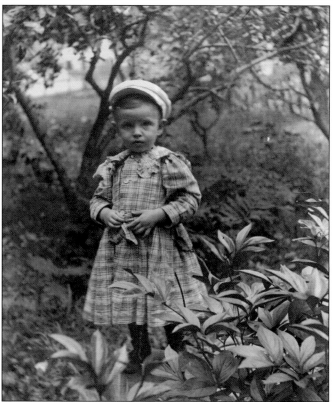

Above, Sid Fort seems to have cajoled (from left to right) his sister Florence and her friends Mary and Sila to pose in their best finery in his backyard in 1897. The girls, showing an obvious lack of enthusiasm, wore the high-ankle shoes of the day, but hemlines were trending upward and tastes in women's hats varied.

Casey, C.M. Fort's grandson's nickname, was captured on film on August 8, 1897. His apparel was not unusual, as parents did not dress children in gendered clothing until the ages of four or five. This practice continued well into the 1900s.

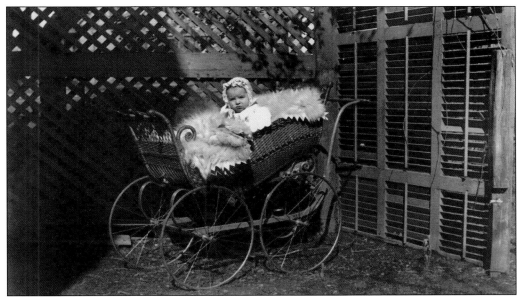

Although not identified as such in photograph notations, it is assumed from his initials and from other photographs in the collection that the C.S. Moody seen here is one of C.M. Fort's grandchildren. The large, tireless wheels permitted maneuvering of the carriage over rough terrain, including unpaved streets. Although the cast-iron carriage was heavier than its modern-day equivalent, the seat appears to be removable.

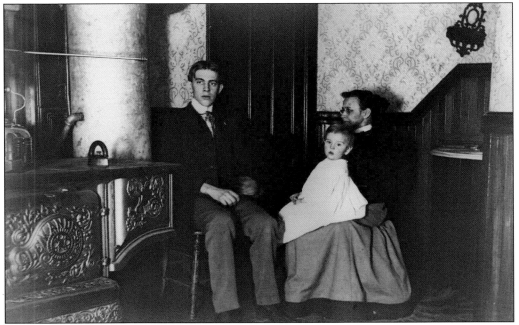

This photograph was taken on August 8, 1899, in the Fort kitchen, next to the Glen Andes stove and the hot water heater. The Forts followed the advice to "keep your irons in the fire" literally, as the iron sits on the stove. These appliances were among the most up-to-date of that era, making the household an exemplar of the Victorian middle-class lifestyle.

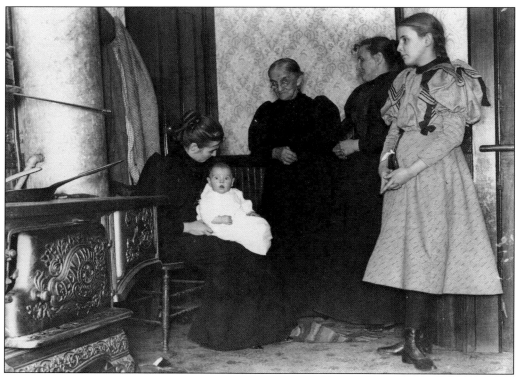

Above, three generations of Forts dote over grandson Cornelius, who seems genuinely surprised by all of the attention. The contrasting hemlines displayed by Flora (right) and the other women hint at coming changes in women's fashions. This Glen Andes stove was regularly advertised for sale in the *Mechanicville Mercury*.

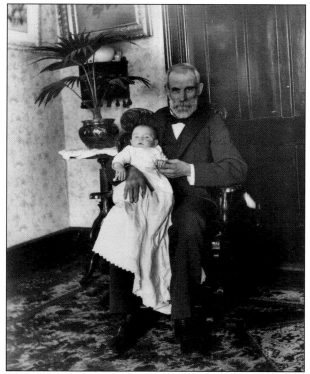

This photograph, titled "C.M. Fort and Little Cornelius," was shot in 1898. C.M.'s steady gaze at the camera exudes the pleasure every grandfather has when holding his pride and joy. Although C.M. appears to be in fine fettle here, soon after, he asked his son to take a more active role in the family business because of undisclosed health issues.

Sid Fort had a protégé, perhaps Flora, help him shoot the photograph above, "Two Spiders and Myself," and others like it in his backyard in 1898. The young boys are unidentified, and Fort did not have any brothers. Straw boaters were the order of the day for young men, while boys commonly wore caps and bobby socks. Fort's pegged pants were typical of bicyclers, or "wheelmen," at the time. Men's and boys' clothing styles did not change for more than another generation.

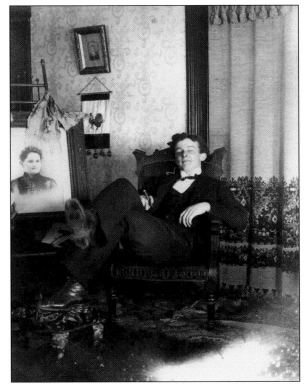

Egbert Bostwick appears quite at home while visiting "Russell's Parlor in 1898." Bostwick, then 22, spent most of his career as a bookkeeper at the local paper mill, according to census records and the 1930 city directory. Like the Fort home, Russell's parlor displayed many of the accoutrements of middle-class Victorian domesticity. Cigars were generally smoked indoors at the time.

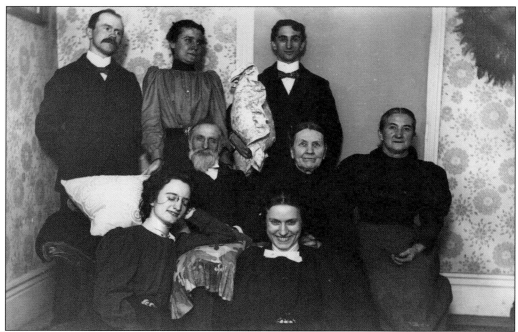

A full range of emotions is captured here in this 1899 "Flash at Carpenters." The Carpenters, family friends of the Forts, resided on Court Street (now Grand Street). What the gentlemen in the rear is holding in his left hand will forever remain a mystery. Although it was taken only a year after he is seen on page 40, C.M. Fort appears to have aged greatly in the interim.

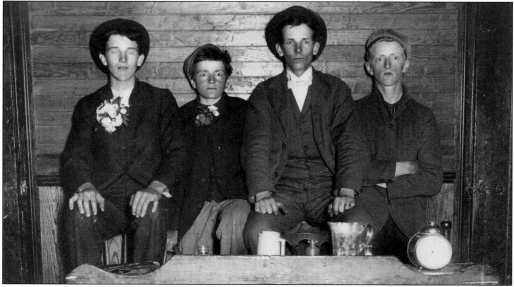

Early in his photographic career, Sid Fort captured four of his friends "unofficially" enrolling in night classes at "Wendell's School House." The bug-eyed appearance of these subjects was likely due as much to their inexperience at posing for the camera as to their being caught breaking into school. The wedding ring worn by the man third from the left and the corsages worn by the two on the left leave many questions about what exactly they were up to.

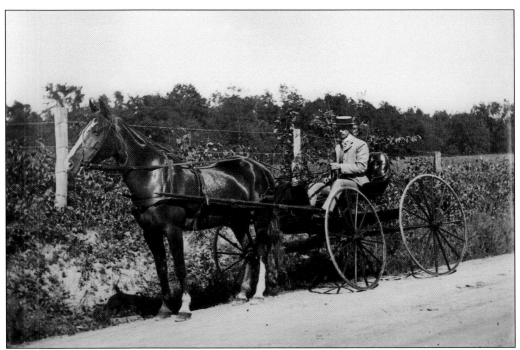

"Dr. Shossy and his horse and wagon" stopped in 1900 to pose for young Sid Fort. It is unlikely that the doctor was making a house call, but it is clear that Fort had a penchant for convincing people to pose for him.

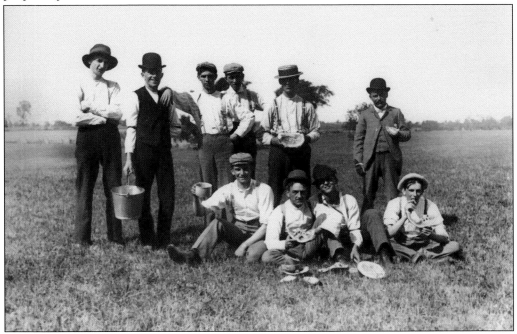

One of a series taken in the summer of 1899, this photograph captures young men "Eating Watermelon at Bill Baker's" following a game of baseball at a farm in nearby Stillwater.

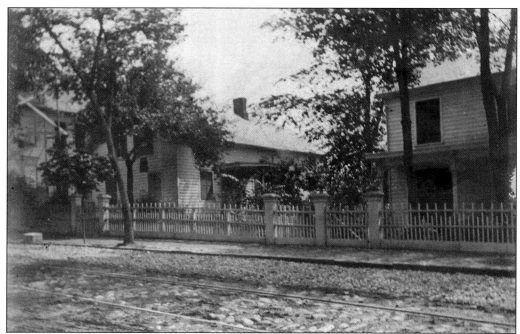

North Main and William Streets are seen above around 1900. The toll bridge erected in 1887 was 500 feet south of this scene, but the 1950 bridge was built in this area. This photograph bears no resemblance to today's neighborhood, indicating how drastically some areas have changed. (MDPL.)

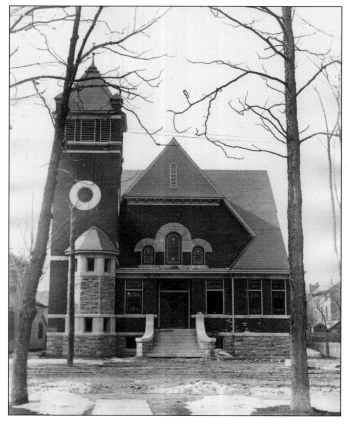

Few of Sid Fort's photographs focus on buildings, but this portrait of the Presbyterian church on South Main Street, across from the post office, was taken shortly after its completion in 1898. The Presbyterian and Baptist congregations merged in 1974, and this church was torn down to make way for a chain store parking lot.

Three

THE RISE AND FALL
OF THE PAPER CITY

Younger residents driving past Price Chopper Plaza today see a mall, while older residents retain visions of 50-foot-high woodpiles entering sluiceways as logs and coming out the other side as finished paper. The paper mill was never closed, running 24 hours a day, 7 days a week, 365 days a year. It never had; never would. Or so it seemed. Life's daily rhythms were signaled by three whistles announcing shift changes. Generations came and went with these images in mind.

The Hudson River Water Power and Paper Company dammed the Hudson River in 1885, just downstream from the mouth of the Hoosac River. Initially selling pulp fiber to other mills, by 1896, it produced 40 tons of paper per day, used primarily to print hymnals. *Paper World* described the plant, by then known as the Duncan mill, as "a model of a modern mill." Meanwhile, hydropower interests organized a new venture, building another dam one mile to the south, which pioneered innovations in the electrical industry.

Subsequently, a movement of papermaking mergers created giants like the International Paper Company. Consolidation reached Mechanicville in 1904, when the Luke family purchased the Duncan mill and integrated it with five other eastern plants operated by the Westvaco Corporation.

By 1954, labor and management had converted the Mechanicville mill into the largest book-paper plant in the world. Simultaneously, Westvaco chemical engineers experimented to expand the range of paper-made products. However, labor-management conflicts provoked two strikes, closing the mill for lengthy periods in 1956 and 1959. Although labor peace prevailed thereafter, mill employment slowly declined over the next decade. Then, abruptly, Westvaco ended operations in June 1971.

Many factors contributed to the closure. Expensive mill upgrades were needed, northern forests were declining, and new environmental regulations prohibited further abuse of the Hudson River as an industrial sewer. Seeing the handwriting on the wall, Westvaco transferred operations to new mills in the south, ending Mechanicville's days as "the Paper City." The photographs in this chapter recapture some of what has been lost.

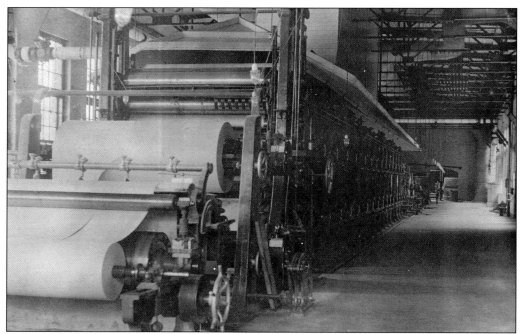

Initially producing wood pulp sold to other mills, the Hudson River Water Power and Paper Company inaugurated papermaking in March 1892. At the time, editor Farrington Mead reported, "One of the big paper machines . . . started last Saturday, turning off a clear, white sheet of calendared paper 60# book paper." A second machine like the one seen here began operating later that year.

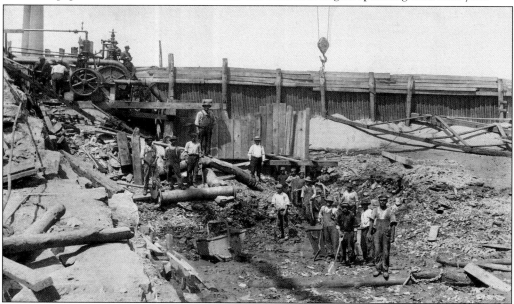

Immigrant workers are seen toiling on the paper mill dam in 1910. Farrington Mead often expressed surprise that more of them were not killed by cave-ins while engaged in such dangerous work. The Champlain Canal relocation of Lock 3 at the dam required reconfiguration of the mill's original 1885 dam.

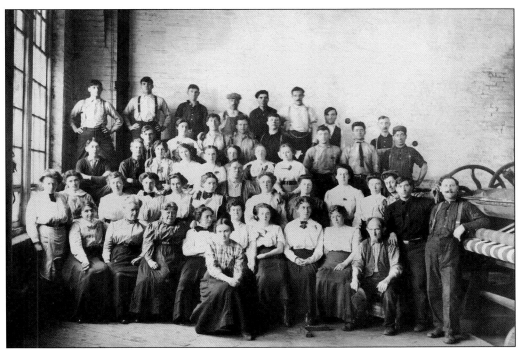

On April 28, 1902, male and female mill workers posed for this photograph in the finishing department. The mill was a classic example of late-1800s industrial architecture, with large windows and high ceilings providing abundant ventilation and natural lighting. (MDPL.)

These Duncan Company employees were dressed in vaudeville apparel, as they apparently had occasional opportunities to produce their own acts while at work. While it is hard to generalize from meager evidence, the mill appears to have been managed in a humane manner. Owner John Duncan lived in the community and was widely respected for his attention to civic affairs. (MDPL.)

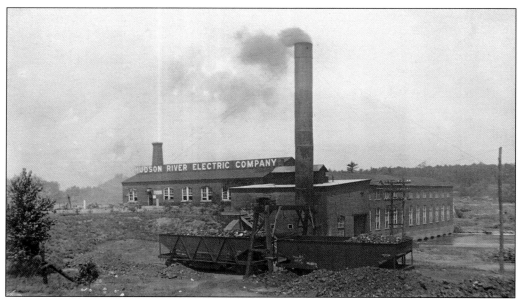

About 1,000 sightseers per day came to watch the building of the Hudson River Electric Company's powerhouse in 1897, when such facilities were a novelty. A group of paper mill investors formed a separate corporation to develop hydropower, enlisting the help of Charles Steinmetz, known as the Wizard of Schenectady, who conducted experiments here that established the supremacy of AC over DC current.

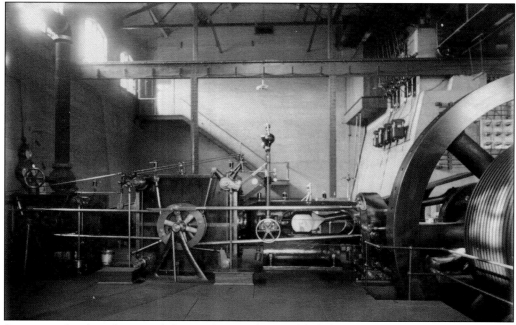

Steinmetz developed some of the machinery that enabled the plant to transmit electricity to General Electric, 17 miles away in Schenectady. Prior to 1900, few people believed that power could be sent such a distance. Before long, the plant produced enough electricity to power electric trolley lines throughout the capital district.

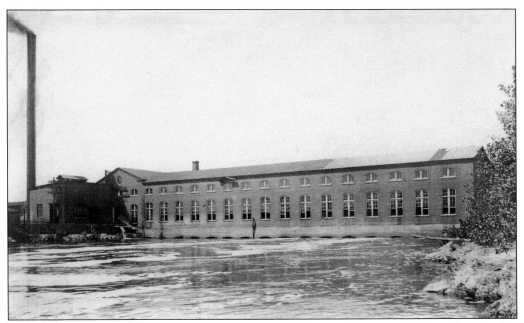

This site, which was added to the National Registry of Historic Places in 1987, was described as an outstanding example of large-scale architecture associated with the burgeoning hydroelectric industry around 1900. It later conducted the first experiments involving the transmission of DC current, and it is the world's oldest three-phase power plant still in operation.

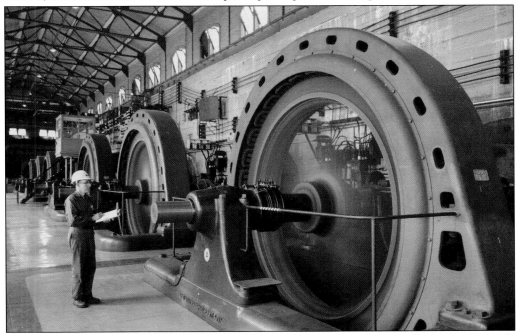

A Niagara Mohawk engineer checks the status of one of the plant's turbines in the 1980s. Currently operated by Albany Associates, Mechanicville South is the oldest continuously operating power plant utilizing original equipment in New York State.

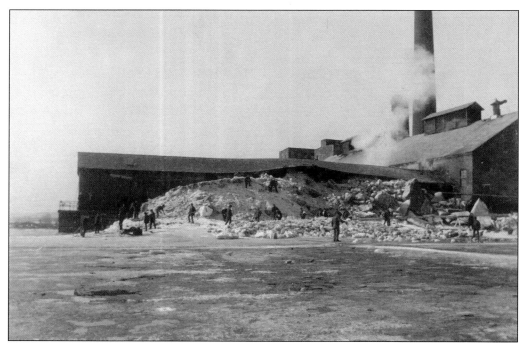

In this photograph, ice is just beginning to collect near the Duncan mill powerhouse. The Hoosac River enters the Hudson just north of the Boston & Maine railroad bridge, and sudden winter thaws often caused ice jams to form at the dam. These men are standing on ice in the river. (MDPL.)

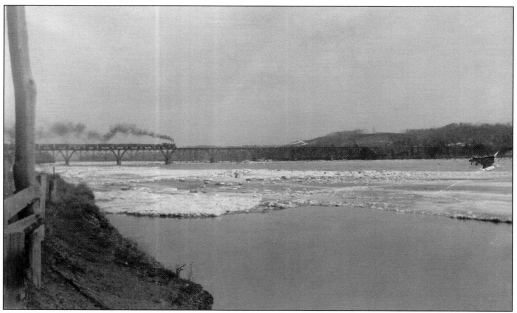

On February 28, 1902, mill supervisor W.J. Barnes recorded this note: "Hoosac high. Ice above dam moved and blocked head gates. Broke in north wall of gatehouse. All mill down." With no source of power, production ceased for one of the few times in the plant's history. (MDPL.)

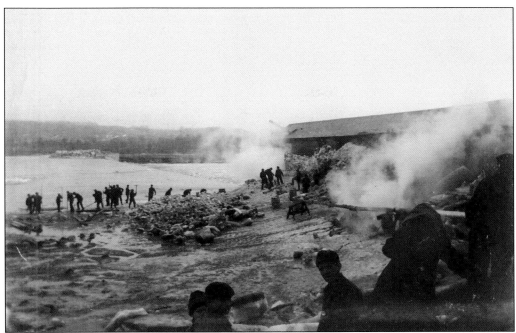

The men above shoveled and chopped ice while the high water in the background flooded over the dam. Steam was also used to melt the ice. Annual flooding and frequent ice jams caused problems for all papermakers on the upper Hudson River, leading them to push for the development of a reservoir system in the Adirondack Mountains to control flooding. (MDPL.)

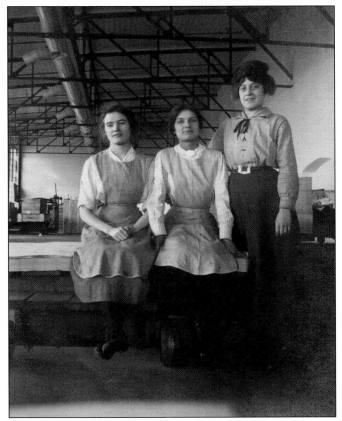

This is one of a series of 13 photographs taken of women working in the cutting room of the Duncan mill around 1900. None of the photographs show sweated labor or a stressful work environment, both of which were typical aspects of American industry in the early 1900s. (MDPL.)

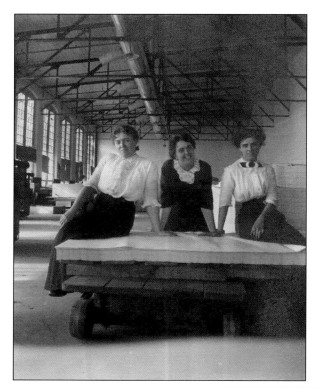

These women resting on a dolly appear to be working in a well-lit, spacious, and clean environment. In the first two decades after it opened, there was never a hint of labor unrest at the mill mentioned in the local newspaper, unlike other Mechanicville industries at the time. Three years after the Lukes purchased the paper mill, a bitter strike ended in 1907, with a large number of mill workers leaving Mechanicville to work in Canadian paper mills. (MDPL.)

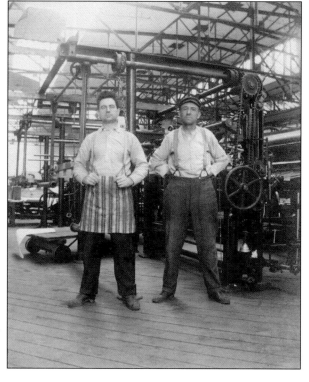

This is one of the few early photographs showing men working in the cutting department. Their labor primarily involved loading paper cuttings for shipping. The paper industry was an innovator in mechanization, and the Mechanicville plant was regarded as a model modern facility. (MDPL.)

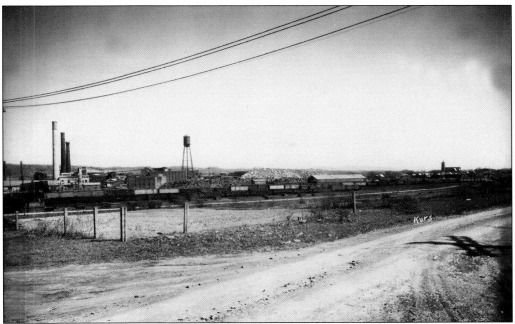

This photograph shows Westvaco's mill and wood yard in the 1930s, which occupied a few hundred acres. Oriented from northwest to southeast, the photograph captures the scale of the operation as well as the importance that railroad connections played in the business. (MDPL.)

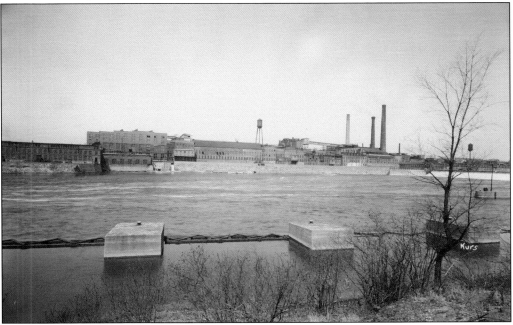

This opposite-angle view, shot from across the Hudson River, shows the powerhouse and pulp-making buildings on the western shore of the river. While providing hydroelectric power for the plant, the river also served as an industrial sewer, with papermaking chemicals dumped freely in it every day.

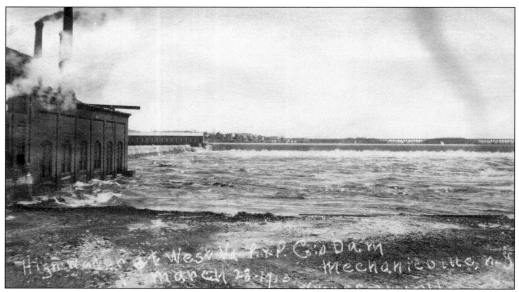

Just as ice jams shut down the mill in 1902, heavy flooding on March 13, 1913, threatened Westvaco's attempts to keep the plant open. The 1913 floods were devastating throughout the Upper Hudson Valley, and set the stage for the creation of the Sacandaga Reservoir system to regulate the river's water level. Mechanicville state senator George Whitney played a leading role in pushing for legislation to create the project. (MDPL.)

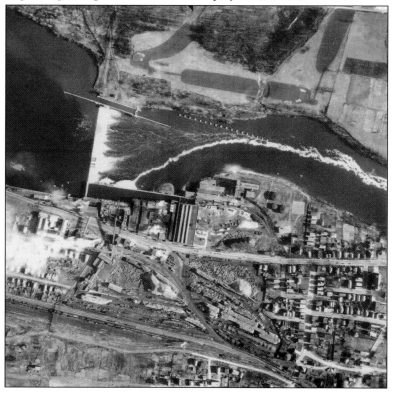

This aerial shot presents another glimpse of the Westvaco plant, the largest book-paper mill in the world when the photograph was taken in November 1945. The power dam and adjacent Lock 3 of the Champlain Canal bordered the Mechanicville Golf Course, which was originally owned by the company. Steam from the boiler house partially obscures the view to the left, while a stream of pollution can be seen flowing into the river.

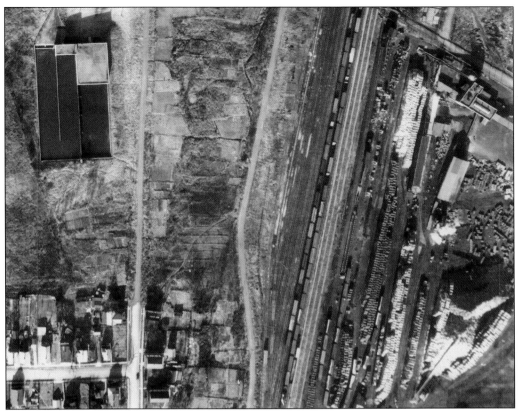

Another 1945 aerial view shows the woodpile, where a constant stream of logging trucks brought wood to be fed into the chipper house. The large building in the upper left processed clean water used in making pulp and paper.

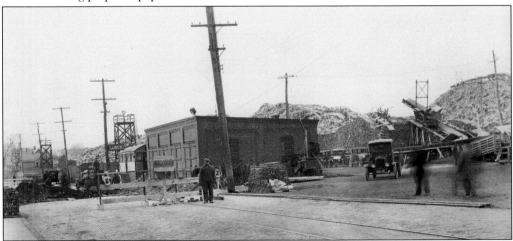

Traffic was detoured behind the paper mill diner (center) while the Boston & Maine rail connections to the loading docks were under repair. Although situated on mill property, these rail connections became a legal bone of contention when workers went on strike in the 1950s, with the company claiming that pickets blocking them were interfering with interstate commerce. (MDPL.)

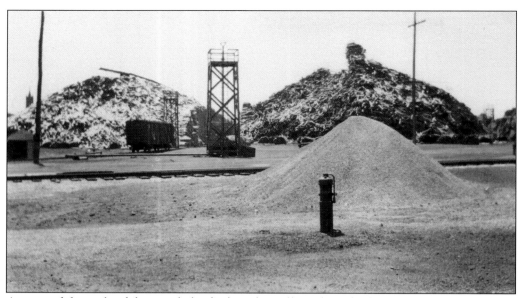

A sense of the scale of the woodpiles feeding the mill can be judged by comparing their height to the railroad boxcar in the foreground. Fire was a constant threat throughout the yard, and mounted water cannons like those seen here were present everywhere on company property. This photograph was taken in 1935. (MDPL.)

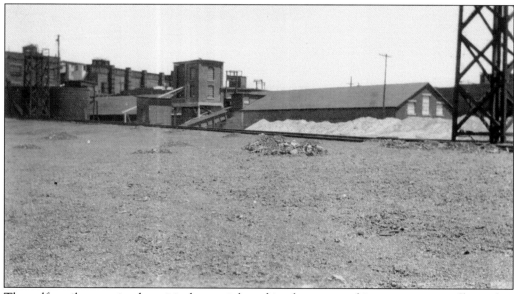

The sulfur pile contained a critical material used in the papermaking process, as well as other chemicals such as chlorine. Local wags contended that travelers could smell Mechanicville before they could see it. The 1915 New York State census listed the occupation of a number of recently hired plant workers, Spanish-speaking immigrants, as "sulfur burners." (MDPL.)

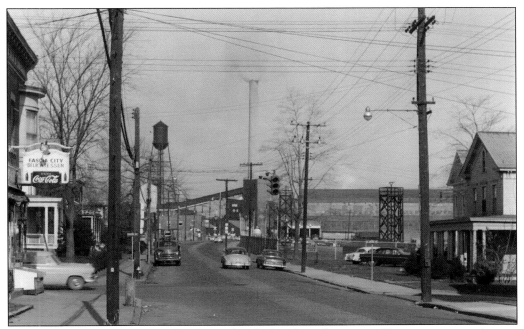

For decades, one of the most familiar sights for local residents as well as tourists traveling to nearby Saratoga was the North Main Street access to the Westvaco mills, which dominated the landscape of both sides of the street in New York's smallest city. The store on the left is now a restaurant. (MDPL.)

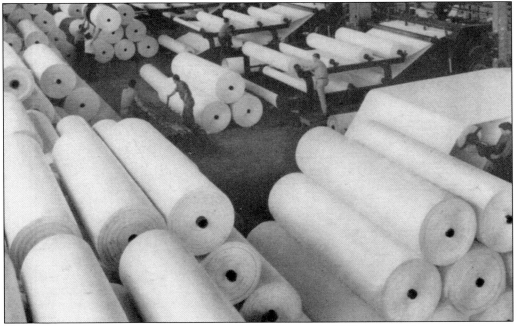

The finishing department crew maneuvered rolls of paper in 1962 that could run to 166 feet in width and weigh as much as 10 tons apiece. This work went on 24 hours a day, 7 days a week, 365 days a year.

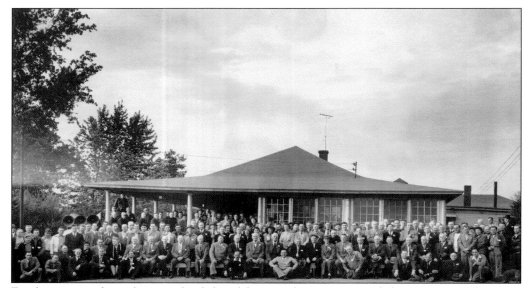

Employees pose for a photograph while celebrating the retirement of plant manager Thomas J. Stirling on September 27, 1947. Stirling guided the mill over a period of 40 years, implementing technological and managerial changes and reaching an agreement in the early 1940s that led to the unionization of hourly employees. The threat of secondary boycotts by Westvaco's customers forced it to acquiesce to collective bargaining. (MDPL.)

Along with 900 hourly production workers, Westvaco employed more than 300 clerks and professionals at its Mechanicville mill. Engineers worked on miniaturized papermaking machines to conduct research on creating new uses for paper products. David Luke, the corporate head and the president of the American Paper and Pulp Association, was a strong proponent of innovation.

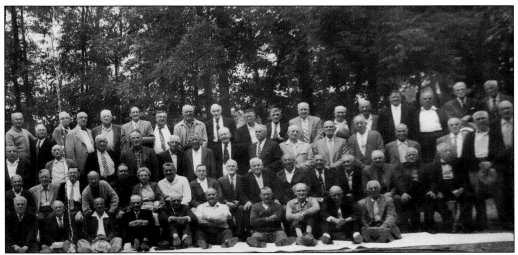

On August 29, 1957, a group of 350 paper mill retirees gathered for a company picnic that mill manager George Hoover described as a "homecoming." Although a strike had erupted in 1907, soon after the Luke family bought the Mechanicville mill, nearly half a century passed before another labor walkout took place, in 1956. If this gathering, just a year later, was an attempt to heal wounds, it did not work, as a second, four-month-long strike disrupted operations in 1959. The sole female employee attending this event was Margaret Murphy (second row, sixth from left). (MDPL.)

This logbook for powerhouse employees shows that most of them were earning 59.5¢ an hour in March 1939, after recently being awarded a 10-percent wage increase. The book records both the names and numbers for each worker. About 20 years earlier, workers were assigned numbers but names were not recorded. Thus, it was not uncommon to read a note in the *Saturday Mercury* to the effect that "an Italian, number 483," had been seriously injured at the mill.

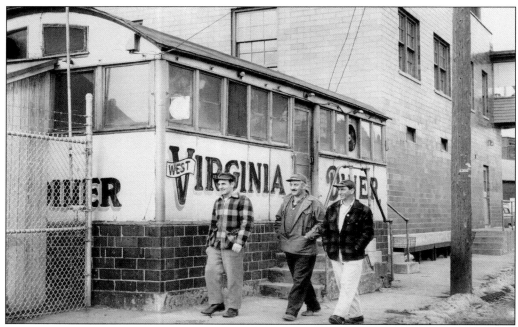

From left to right, Carl Beninati, Frank Izzo, and Joe Esposito leave the Westvaco diner, next to the workers' changing room. Employees who worked overtime were given a meal pass to be used at the diner. After the mill closed, this structure was removed from the property intact by a crane when Hildreth's Diner opened a restaurant nearby.

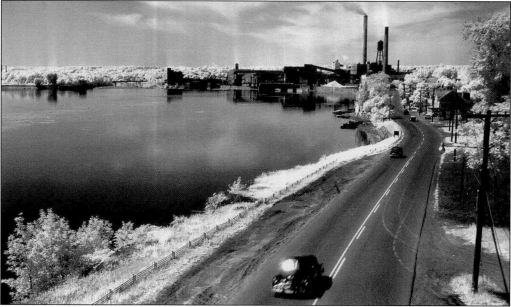

The Westvaco mill operation is silhouetted against the backdrop of rime ice in this 1940s photograph taken from the Boston & Maine railroad bridge. This portion of the Upper Hudson Valley is quite narrow, and the open water created by the powerhouse and plant discharges often created rime ice and fog in cold weather. (MDPL.)

Four

"We've Been Workin' on the Railroad"

Hardly an artifact remains of Mechanicville's romance with railroads. In 1835, the Saratoga & Rensselaer Railway chugged its way through the settlement, transporting wealthy Southerners and European travelers to the spas at Ballston and Saratoga. By 1900, mergers and modernization transformed a sleepy hamlet into one of the busiest freight centers in the United States.

The Boston & Maine (B&M) employed almost 80 percent of the 1,000-man local workforce in the early 1900s, but its intersection with the Delaware & Hudson (D&H) provided it invaluable access to trade with southern Canada. The integral role Mechanicville played in the national economy became apparent in 1917 when Williams College in Massachusetts suspended classes to send students here to break a freight embargo imperiling the Allied war effort.

In 1912, gangs of Louisiana convict laborers and 400 Italian immigrants converted swamplands into a modern rail classification yard, incorporating a roundhouse, stock pens, coal pits, an icehouse, and a powerhouse lighting the yards, increasing efficiency and safety. Railroading was a dangerous business, and *Saturday Mercury* editor Farrington Mead even sought the transfer of the county coroner to Mechanicville because of numerous railroading fatalities.

A decade later, the introduction of the retarder switch—a train brake laid on the track—cut freight transfer times in half, saving lives and labor. However, this innovation also reduced job security, leading the B&M to halve its workforce. Thereafter, Mechanicville's population, which had peaked in 1925, began a long, steady decline.

Railroads continued playing a significant role here throughout the 1960s, but, by 1985, the local yards had been practically abandoned. Pan Am Southern recently partially resurrected them, building automotive and intermodal terminals. While most of the heavy lifting is now performed by automation rather than manual labor, residents are happy to hear the sound of the train whistle once again.

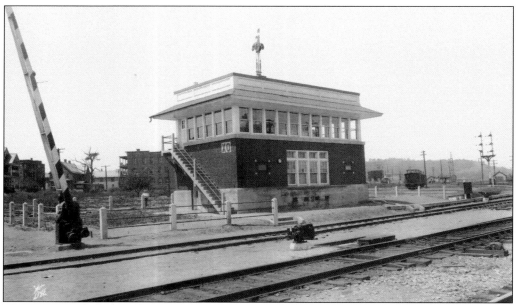

The iconic symbol of Mechanicville's railroad heyday is the XO Tower on Depot Square, seen here in 1914. Following its recent rehabilitation, it looks much the same today as it did then. Much speculation surrounds the supposed hidden meaning of XO, but it is actually quite simple. As noted by longtime D&H railroaders, each yard was assigned a symbol to notify incoming trains where they were, and Mechanicville's happened to be XO. At the western end of the yard, an XY symbol not readily seen by the public went unnoticed for decades.

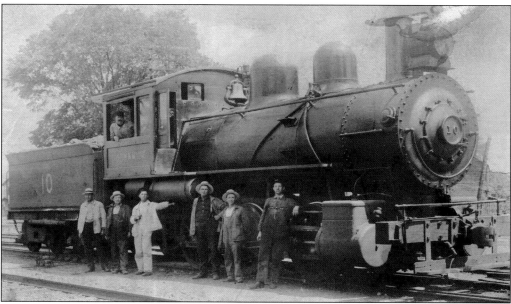

Harold Sawyer (standing, third from left) was a brakeman for the B&M in the early 1900s. B&M controlled the port of Boston, but the Fitchburg Railroad controlled the Hoosac Tunnel's vaunted "Gateway to the West." In 1900, mutual self-interest led to the merger of the Fitchburg and the B&M, and Mechanicville's role as the key rail portal to the West was assured. (MDPL.)

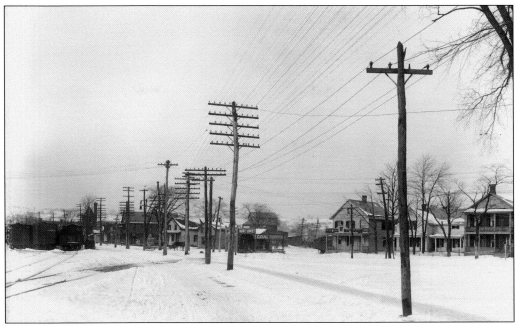

Railroad Street, seen here in 1917, was often more "railroad" than "street," according to Farrington Mead. The crusading journalist, who often referred to the D&H as The Skunk, complained that the D&H used this street as a coal bin for its deliveries to local suppliers. He also charged that the line held passengers, who took the train daily to work in Albany, in contempt. Mead appeared at public service hearings whenever the opportunity arose to lambaste the company.

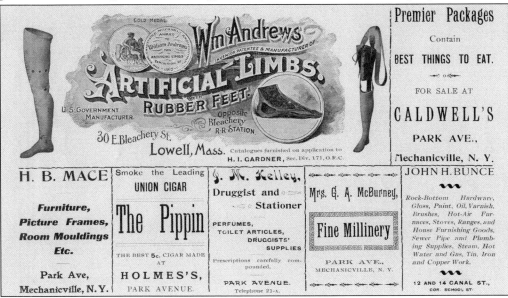

The most prominent advertisement running in the booklet marking the Convention of Railway Conductors held in Mechanicville in 1903 was a grim reminder that more men were killed working on the rails between 1865 and 1914 than died in all American wars during that period. The *Saturday Mercury* carried frequent accounts of deadly rail accidents.

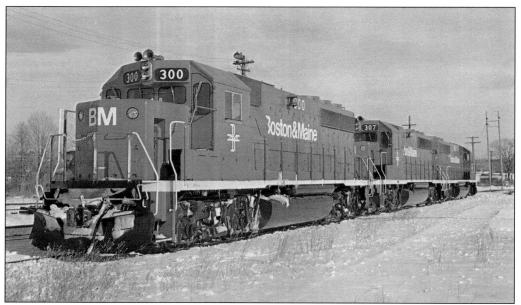

These engines, purchased from Electro-Motive Diesel, held great advantages over steam engines when it came to efficiency. Diesels did not stop to take on water, and they required fewer repairs. In 1943, the *New York Times* reported that for the first time in its history, the B&M had sent a mile-long freight nonstop from Boston to Mechanicville, cutting more than four hours off the usual trip. The days of steam engines were numbered, although many railroaders never held diesels in high esteem.

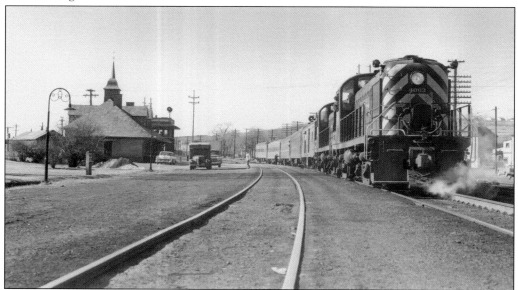

The Montreal–to–New York City *Laurentian*, seen here, featured an observation car and stopped in Mechanicville twice a day. Additionally, commuter trains ran five days a week, carrying many local residents to work in Albany, a service that disappeared in the early 1960s. Recently, there has been some discussion of reviving commuter service between southern Vermont and the capital district. (MDPL.)

George Hannauer, who left the Illinois Central Railroad to take charge of the B&M, introduced the innovative retarder switch, a brake laid on the track. It increased efficiency and safety, as brakemen no longer had to ride atop cars, rolling off of the hump while making up new trains.

The B&M line followed the Hoosac River from the west portal of the Hoosac Tunnel to near Mechanicville, where it crossed the Hudson. Washouts like the one below were not infrequent occurrences along the line, as spring thaws were—and still are—the cause of large ice jams that flood roadbeds. Originating in the Berkshire Mountains, water levels on the Hoosac can rise in a matter of hours, creating the threat of flash floods.

February 4, 1928 RAILWAY AGE 29

HUMP-YARD LAYOUTS PRODUCING LARGE SAVINGS

Mechanicville Yard equipped with new Retarder System and using new principle of layout. Only 17 retarder units required for 36 classification tracks. The yard is unusually fast.

THE design of the new G-R-S Retarder is so superior to previous designs, with its greater strength, braking power and equalized pressure that we feel safe in predicting that future designs which may be brought out will be modeled on it.

With a single source of power and the remarkable simplicity of the parts combined with new principles in yard layouts, few railroads can afford to be without this modern equipment.

Our expert on Classification Yards is at your service.

ROCHESTER N.Y.

New York Chicago St. Louis
London Paris Melbourne

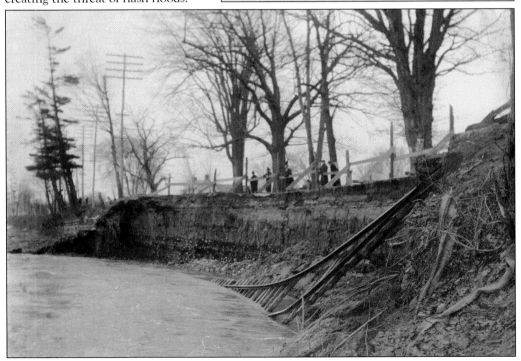

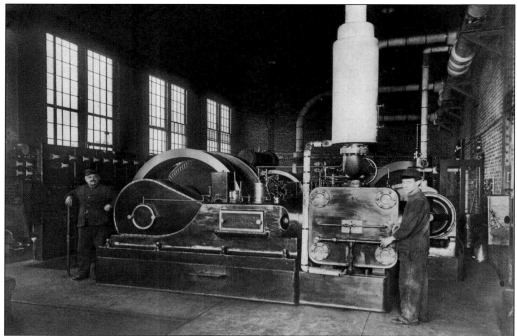

One of the chief innovations introduced with the expansion of the B&M yards in Mechanicville was the erection of a powerhouse that fed the machine shops and turntable and also provided nighttime lighting that expanded the workday. For generations, Mechanicville residents returning home at night were guided by the rail yard lights, which were visible from long distances.

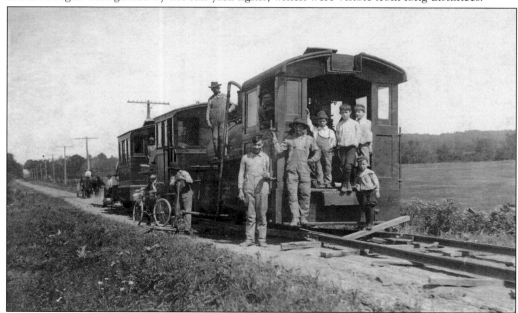

Every boy's dream was to ride on a train. Here, many got to realize their wish, as passengers on a service train working on the relocation of the Champlain Canal in 1910. The lure of the railroad tempted many young men to leave school early in hopes of becoming railroad engineers.

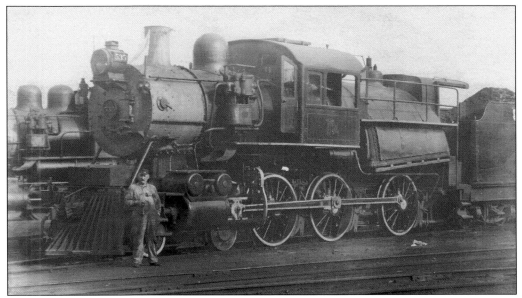

The 535 was one of the older steamers working the Mechanicville yard in the 1890s. The D&H began running trains through Mechanicville after purchasing the Saratoga & Rensselaer Railway in 1870. Yard activities expanded dramatically in 1900, when the B&M decided to make Mechanicville its "Gateway to the West." (MDPL.)

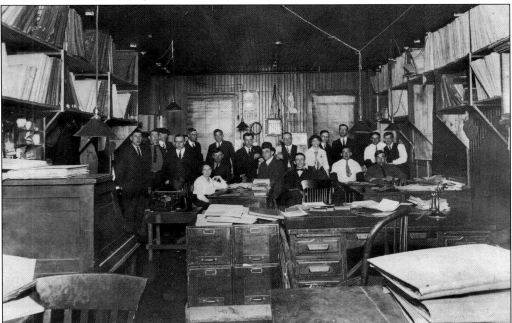

D&H transfer dock office workers are seen here around 1900. Coats and ties were the order of the day, and, although women had replaced male clerks in many industries, railroading was still largely a man's world. That would change, at least temporarily, during World War II, when the shortage of men created opportunities for women. However, after the war, it was still rare to see a woman climb aboard an engine or be found working in the yard.

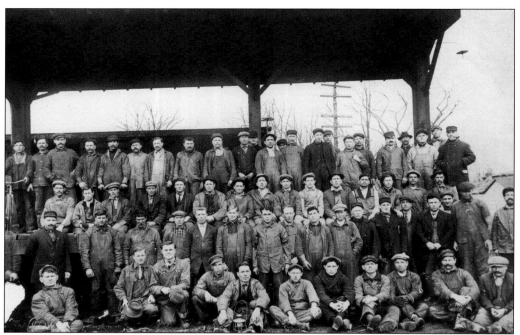

D&H dockworkers, seen here in the early 1900s, began freight transfer operations with the Fitchburg line in 1894, but larger operations began when the B&M bought out the Fitchburg in 1900. As late as 1954, the D&H employed more than 200 men here, most of them transferring freight.

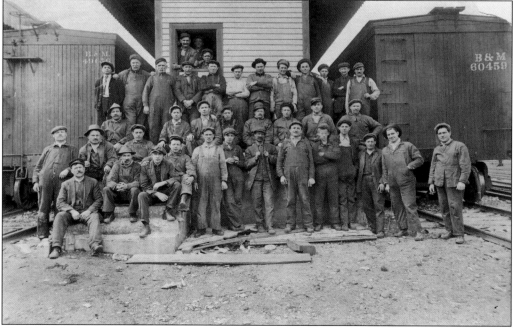

The B&M dockworkers are seen here in "Siberia," the first yards in Mechanicville, which were located north of Saratoga Avenue, adjacent to the paper mill. This locale seemed particularly inhospitable because of the cold winds blowing down the Hudson River onto the unprotected yard.

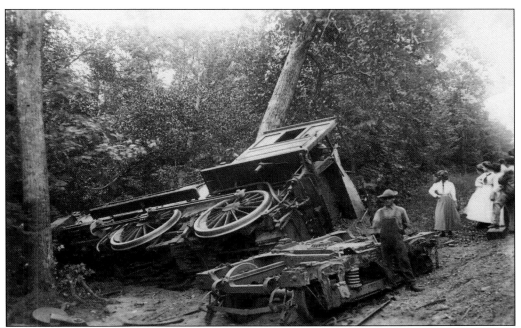

Accidents happened, as seen here with the derailment of a small yard engine. Editor Farrington Mead often expressed shock and horror at the number of serious dismemberments and deaths that occurred here. Yet, he went to exceptional lengths to report the distances that various body parts traveled when human flesh met the iron horse. (Courtesy of John Caruso.)

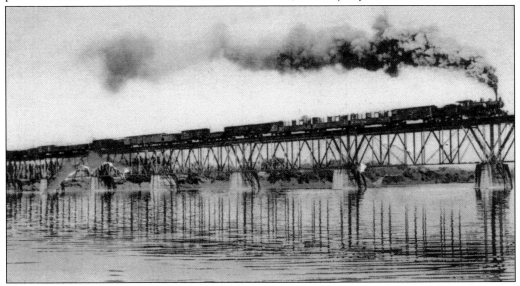

Originally built by the Boston, Hoosac Tunnel & Western Railway (BHT&W) in 1879, this Whipple truss bridge marked a major crossing of the Hudson, its importance gauged by the number of lawsuits filed to gain control of Boston's access to the West. The BHT&W was purchased by the Fitchburg line in 1887, which in turn was bought out by the Boston & Maine in 1900, ensuring the line access to the American heartland and allowing it to compete with the New York Central Railroad.

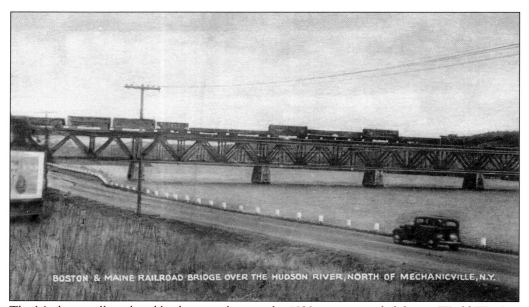

BOSTON & MAINE RAILROAD BRIDGE OVER THE HUDSON RIVER, NORTH OF MECHANICVILLE, N.Y.

The Mechanicville railroad bridge, seen here in the 1930s, was upgraded during World War I to accommodate larger engines and longer trains. Its importance was revealed in 1917, when the federal government stationed armed troops on either side of the bridge to prevent sabotage.

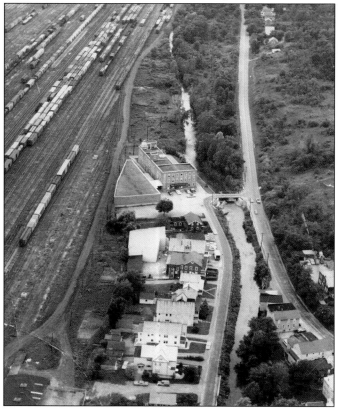

This aerial photograph shows three aspects of Mechanicville's history. Wedged between Route 67 and the north end of the rail yards, the Tenendehowa Creek attracted the first settlers here in the 1760s, when they built a gristmill along its shores. Route 67 follows a path laid out by travelers in the early 1800s, who turned west from the Hudson on their way to the spas of Ballston and Saratoga. And, thirdly, the rail yards seen here, which were built in 1912, lay along the track bed that was first created by the Saratoga & Rensselaer Railway in 1835. The building at the top was owned by the National Cash Register Company and was destroyed by fire in the late 1960s. (Courtesy of John Caruso.)

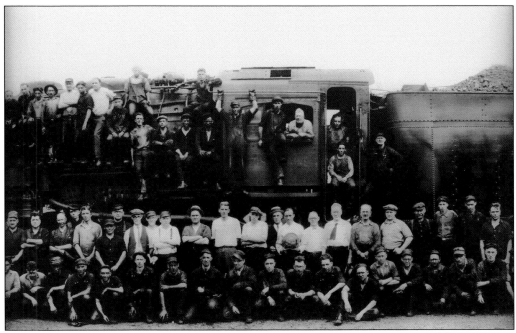

About 125 men worked on the B&M's mechanical train crew in 1926, at the height of the company's operations. The work crew was significantly reduced when diesels replaced steam engines in the 1940s. Diesels required less maintenance and could be put back in service in a matter of hours, compared to the days or weeks required to fix steam engines. (MDPL.)

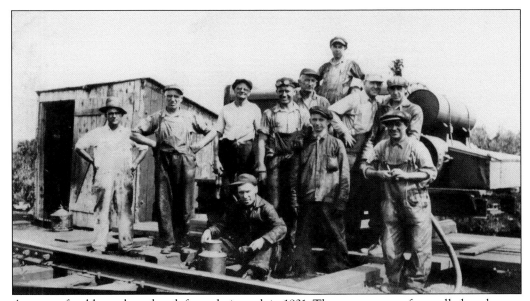

A group of welders takes a break from their work in 1931. These men were often called to clear up problems, like derailments or other emergencies, which had arisen anywhere along the railroad's route. (Courtesy of Joseph Waldron.)

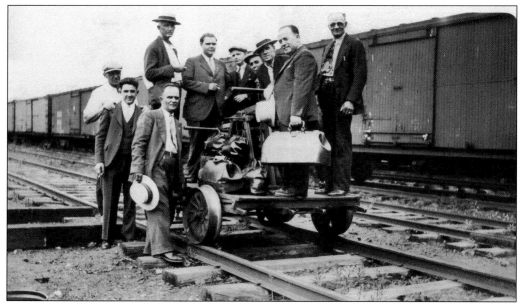

Standing on the tracks in this posed photograph are, from left to right, Paul Leary, Fred Boucher, and foreman J.A. Gagne. The men on the handcart are unidentified. Trackmen replacing rails at remote sites often commuted in this manner, back and forth from the yards. (Courtesy of Joseph Waldron.)

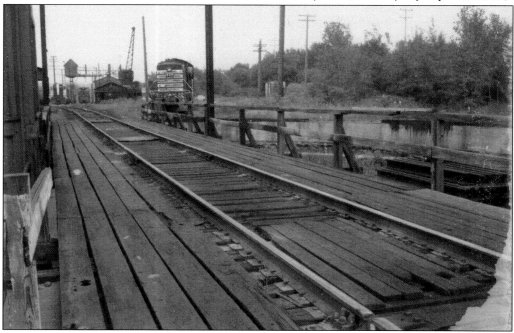

The engine in the center right is lined up to board the turntable in 1971. By then, the roundhouse had been torn down and little mechanical work was performed in the yard. The B&M had gone into receivership, and its operations were being overseen by a federal bankruptcy judge. Guilford Transportation purchased the line, but the Mechanicville facility was virtually abandoned by the 1980s. (MDPL.)

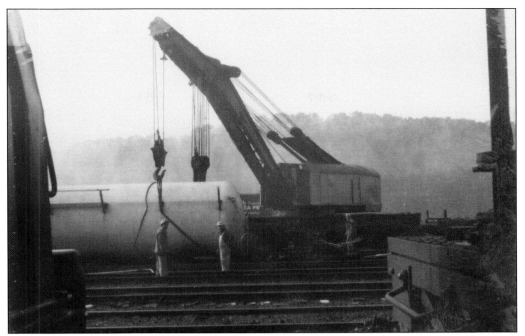

A runaway propane tanker derailed and crashed into the garage at Depot Square in 1969, leading to a temporary evacuation of the surrounding neighborhood. Fortunately, the car did not rupture, and the delicate job of re-righting it was successfully carried out without further incident. (MDPL.)

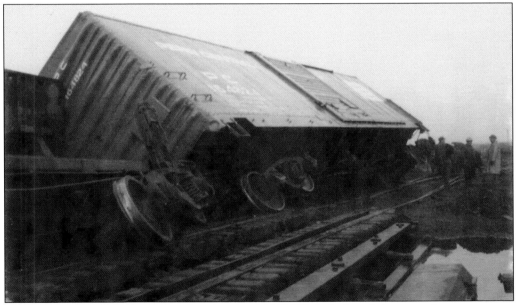

Another wreck occurred in the local yard in April 1969. While far from being everyday occurrences, wrecks were not that unusual, adding to the other dangers railroaders faced every day. At its height, the B&M handled about 6,500 freight cars per week, while the D&H turned over about 600 per day. (MDPL.)

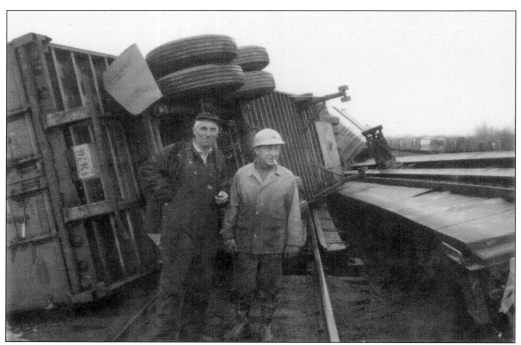

Al Morby (left) and Vince Zielnicki pause while getting ready to grapple with what, for them, was just another day at the shop in the local rail yard. Such work was not for the fainthearted. (MDPL.)

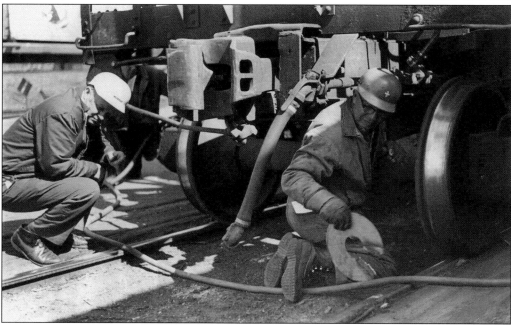

Russ Gordon (right) gets up-close and personal with a freight car while replacing axle wear plates, with his foreman (left) looking on. This photograph conveys some of the scale of what workers dealt with. Any false step or unintended movement of a car had serious consequences for anyone who got in the way. (MDPL.)

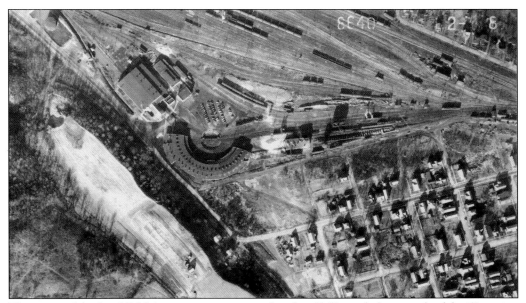

The scope of the local B&M operations is captured in this 1945 aerial photograph of the 52-engine roundhouse, on the south end of the two-mile-long yard. The small houses in the right foreground are on Mechanicville's west side.

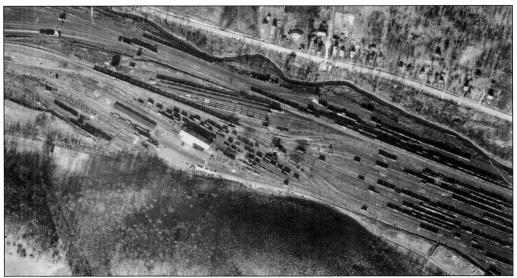

Another aerial photograph shows the north end of the yard, where trains were reclassified and broken down along 26 tracks laid out in the pattern shown in the drawing on page 65. When the yard was built in 1912, the Tenendehowa Creek was diverted to the north to open the way to lay 60 miles of track along a two-mile path.

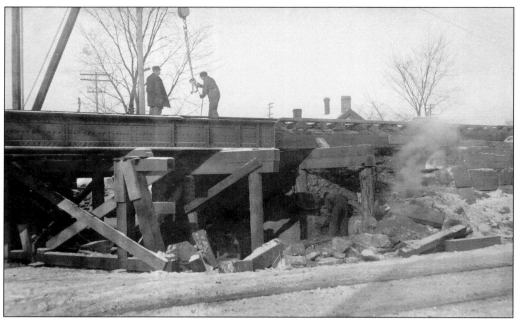

Workers rebuild the Dutch Gap crossing on South Main and South Streets in the 1930s. Travelers in the 1800s had to cross these tracks above grade. In 1871, the Saratoga, Rensselaer & Whitehall Railway agreed to follow the Union army's strategy when they faced Richmond and dug a path under the tracks. The choice of terminology may reflect the fact that the crossing was located near Col. Elmer Ellsworth's home.

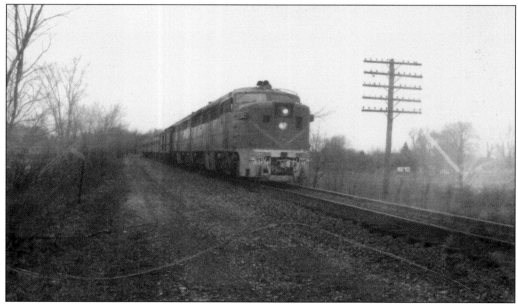

John Maloney, city historian and newspaper columnist, shot this photograph of the "last train south." The regular running of the *Laurentian* between New York and Montreal ended in 1971. It was revived for a short period, but passenger train service is now a thing of the past for Mechanicville and most of the communities in upstate New York. (NDPL)

Five

IF THEY COME, YOU WILL BUILD IT

Fortunately, education is not what is used to be. In the mid-1800s, Mechanicville students learned little more than the "Three Rs" in the two country schools established by the local town boards governing the village. Parents hoping to provide their children with more than a rudimentary education could send their children to the private Mechanicville Academy, but only if they could afford the tuition. Located on South Main Street, the academy offered programs from kindergarten through 12th grade and accommodated out-of-town boarders between 1859 and 1891.

Free, comprehensive public education became available when the newly created Mechanicville School District opened a school in November 1888. Population growth over the next two decades compelled the district to open five neighborhood elementary schools. As late as the 1950s, Mechanicville still attracted nonresident, tuition-paying students from outlying areas that lacked comprehensive education programs. In 1926, St. Paul's School enrolled 126 students in kindergarten through eighth grade. Staffed by the Sisters of St. Joseph, the Catholic school operated until 1989.

Today, a series of consolidations and building projects initiated in the 1960s and completed in 2002 created a system whereby all of Mechanicville's public schools are located on a large campus in Halfmoon, originally purchased to provide athletic fields for the district's students.

On November 13, 1897, *Saturday Mercury* editor Farrington Mead noted, "The encouragement of athletics among high school students is likely to make school . . . more attractive." Mead alluded to the difficulty of keeping students enrolled beyond eighth grade at that time. The convergence of a number of factors ameliorated the problem in the coming years: New York State raised its compulsory school attendance age to 16; Mechanicville's Irish, Italian, and Polish ethnic groups increasingly recognized the importance of education in achieving upward social mobility; and the development of competitive athletic teams provided the opportunity for a diverse population to overcome ethnic conflicts and forge a strong community identity.

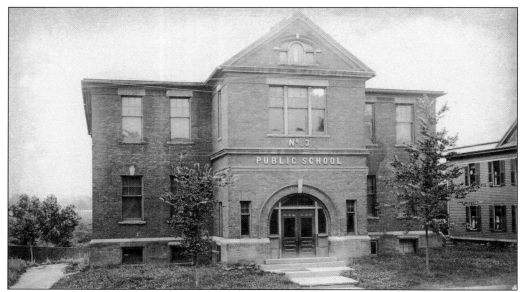

School No. 3, erected in 1895 on Saratoga Avenue, educated the children of Italian immigrants concentrated in the North End, who began arriving in the early 1900s. In the 1920s, the challenges they presented to the English-speaking teaching staff led the board of education to award a 10-percent bonus to teachers who survived a year there. A similar program was implemented in School No. 4 in Riverside, which educated many Polish-speaking immigrants at that time.

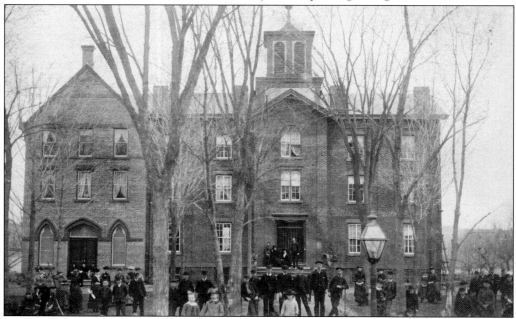

The Mechanicville Academy, on South Main Street, was a private, coeducational school that took in boarding students. Seen here in 1880, the school offered kindergarten through post-graduate and college preparatory programs. Rev. Bernice Ames and his wife, Sarah King Ames, headed the school for 26 of the 32 years it operated. Typically referred to by locals as the Ames Academy, it closed in 1891.

This list of eight reasons to send your children to the academy included the note that it was located in a "pleasant and healthful . . . railroad centre." Whether or not students found the steam engines that passed daily across the street from the school to be healthy was not recorded. The school was converted into apartments after it closed, and the building was destroyed by fire on Christmas Eve, 1948.

Based upon the number of stars in the flag hanging in front of the building, the photograph below of the new Mechanicville School was taken in the early 1890s. While it originally did not include an organized high school, an "academic department" did prepare students to earn a high school diploma. The building was destroyed by fire on February 17, 1919, and was replaced by School No. 1, which served the district until the mid-1970s.

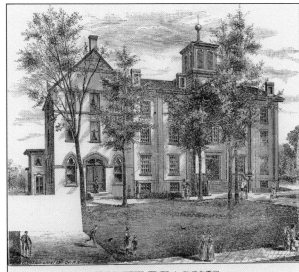

EIGHT REASONS

IN FAVOR OF SENDING YOUR SONS AND DAUGHTERS TO THE ACADEMY, MECHANIC VILLE, SARATOGA CO., N. Y.

1. The village in which it is located is pleasant and healthful, and being a prominent railroad centre is accessible from all points.
2. The building is cheerful in aspect, convenient in arrangement and in good repair.
3. The instruction is of wide range and very thorough.
4. The school is of such limited size that each member receives daily personal attention from the principal and teachers.
5. The atmosphere is eminently homelike and cultured.
6. Good manners and the usages of polite society are inculcated as an important branch of education.
7. Young children, who, for any reason, have to be sent from home, receive special care.
8. Rates are reasonable.

CALENDAR.

Spring Term begins March 21; ends June 17.
Fall Term begins September 5; ends December, 2.
For particulars call upon or address the principal,

MRS. S. E. KING AMES.

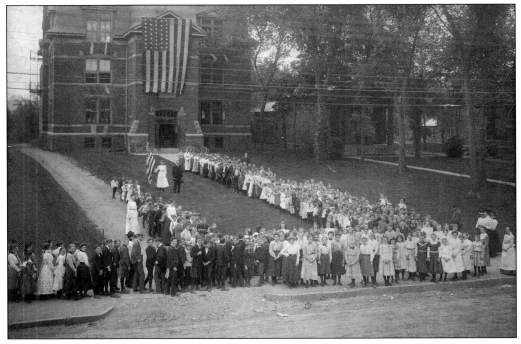

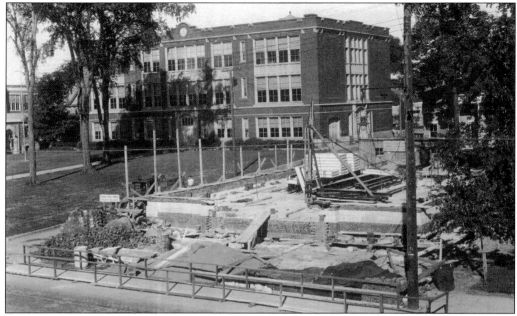

The new Mechanicville post office was adjacent to School No. 1, which was built in 1920. While awaiting the completion of the school building, students were assigned to other schools, or, in some cases, to available factory space. The superintendent solicited public opinion regarding the advisability of shortening the school day to accommodate double sessions. Some parents expressed concerns that too much free time would lead their children to get into trouble.

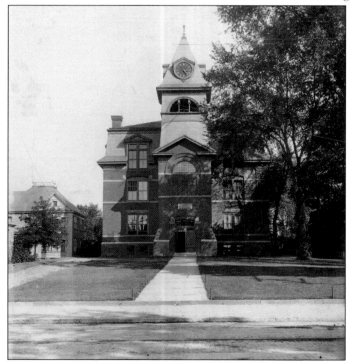

The community took great pride in the clock tower in the 1888 building, which included a beautiful chime and bells. The clock was guaranteed to lose no more than a minute per month over its first three years. It was later recalled that the bell was striking 9:00 when the tower crashed to the ground on February 17, 1919.

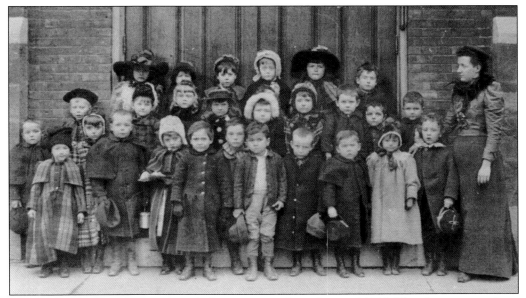

The clothing style of these young scholars suggests a date of around 1900. The class appears about evenly divided between boys and girls, a ratio that would swing in favor of the girls in later years as boys often dropped out to find employment. (MDPL.)

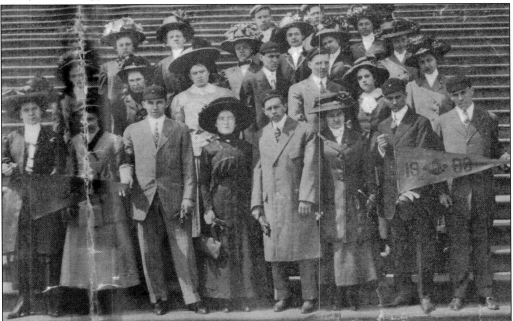

Student trips to the nation's capital are not a recent occurrence. Here, the graduation class of 1909 poses on the steps of the Capitol. Some of the students included, in no particular order, are Stan Turner, Harvey Davenport, Ella Steadman, Teresa Hires, Mary Bailey, Margareta Leyland, Frank Bryan, Floyd Baker, Lota Farnam, Marion Packer, Margaret Bendon, Stella Lee, Theodore VanVeghten, teacher Mary Sullivan, Lowell Eckerson, chaperone Dr. Novey Clapp, Ruth Raymond, and Robert Heywood.

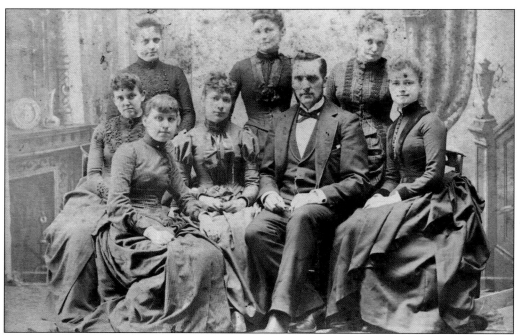

The Mechanicville Elementary School teaching staff in 1902 included Principal Lyman Blakeman and the seven female teachers seen here. Simultaneously, George Martin, the high school principal, oversaw an instructional staff of 19 teachers, indicating that interest in earning a diploma had increased greatly since 1887–1888, when the Mechanicville system was consolidated. The high school had 15 graduating seniors in 1902.

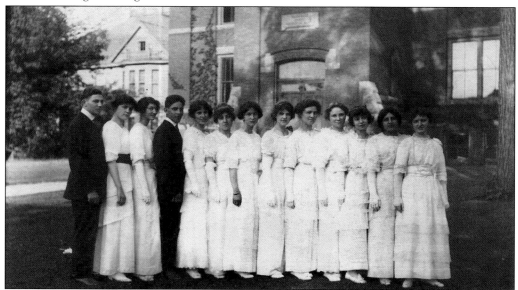

This is the first known formal photograph of a Mechanicville graduating class. The graduates of 1913 were, in alphabetical order, Helen Allen, Earle Clarke, Alice Devoe, Minnie Eastman, Carmina Enzien, Marie Farnan, Norma Hearty, Irene Holloran, Wilford Johnson, Bertha Lee, Mildred McBurney, Henrietta Noonan, and Jennie Sheffer.

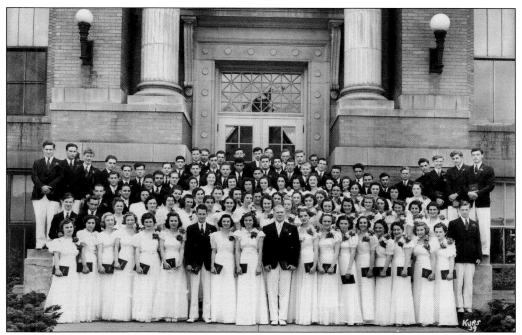

Students continued to wear formal attire at graduation ceremonies through 1939, when this group posed on the steps of Mechanicville High School, which was built in 1914. During the Depression, the expense of acquiring or renting formal dress may have been onerous for some families. (MDPL.)

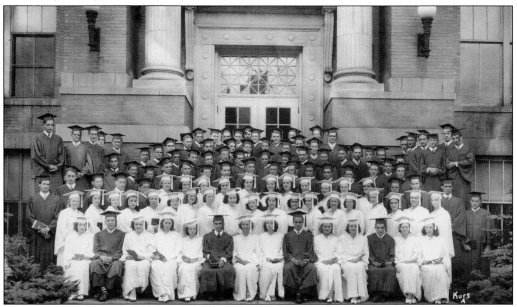

The class of 1940, seen here, was the first group of graduates to wear caps and gowns. That year, there were more males than females, while the year before (above), there had been more females. Perhaps having to do with this is the fact that in the late 1930s, a large contingent of local young men worked at the Civilian Conservation Corps (CCC) camp in Stillwater. (MDPL.)

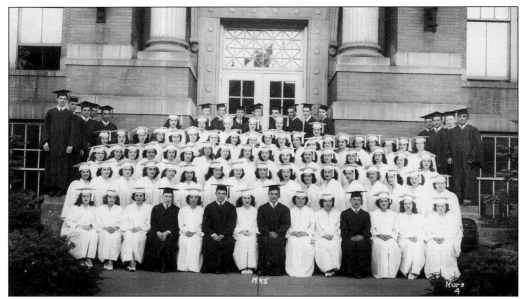

The relative absence of males is starkly obvious when comparing this class photograph with its predecessors on the previous page. As was the case throughout the United States, Mechanicville young men joined the armed forces soon after Pearl Harbor, and school enrollments dropped dramatically. The greater Mechanicville community lost 53 men in World War II, most of whom had attended Mechanicville High School. This number was far out of proportion to the local population when compared to other communities. (MDPL.)

St. Paul's School, seen here under construction on William Street, enrolled students in kindergarten through eighth grade beginning in 1926. Staffed by the Sisters of St. Joseph, the institution was opened to the children of the parish and continued in operation until 1989. At a critical point in Mechanicville's athletic history, St. Paul's gymnasium became the temporary home of the local high school team, which could not accommodate the crowds that wished to see its games. (Courtesy of John Caruso.)

The St. Paul's School second-grade class of 1951 included, from front to back, (far right row) Dianne Moore, Mary Agnes Rowe, Donna Sullivan, Carol Bonesteel, Sharon Gordon, Donna Palmer, and Jane Cunningham; (second row) Joann McMahon, Shirley Pierre, Helen Lemrow, Rosemary Burgoyne, Peggy Manso, Katherine Nolan, and Anita Alvarez; (third row) John Collins, William McEchron, James Bonesteel, Michael Burgoyne, Thomas Fitch, and Ronald Partak; (fourth row) William Kelley, Raymond Quackenbush, Daniel Pickett, Leonard Desmond, David Bahan, William Stalter, and Kent Crotty. (Courtesy of John Caruso.)

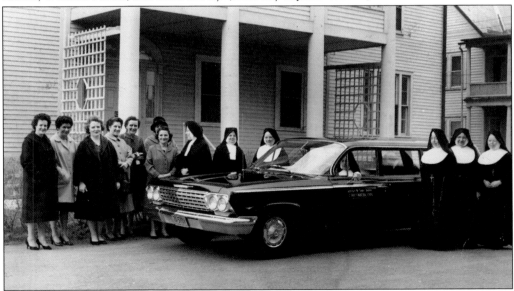

The St. Paul's Mothers organization presented the Convent of St. Paul's with a 1962 Chevrolet, purchased by collecting green stamps from fellow parishioners. Tom Ryan of Sibley Chevrolet (not shown) presented the keys to Sr. Thomas Denise, the second nun from the left. The others are unidentified. (MDPL.)

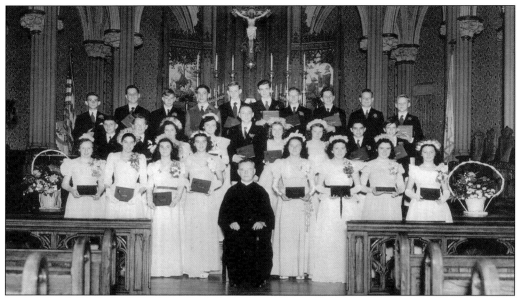

St. Paul's eighth-grade class of 1948 included, from left to right, (seated) Fr. Patrick Campbell; (first row) Margaret Powers, Joan Bisson, Marie Gaudette, Patricia Roy, Patricia Sullivan, Sylvia Fusco, Margaret Dugan, and Catherine Dunbar; (second row) Thomas Roberts, John Holland, Katherine Palmieri, Eileen Reilly, John Nolan, Nancy Louprette, Barbara Moore, James Lenane, and Donald Furlow; (third row) Vincent Lanzone, Earl Wixted, Robert Viall, John Furlow, John Allen, Robert Fitch, Charles Fox, Joseph Hmura, unidentified, and John Lenihan. (Courtesy of John Caruso.)

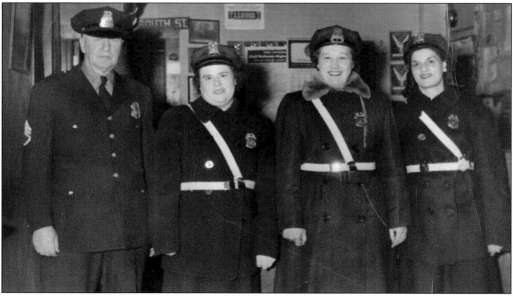

A familiar sight in many communities, crossing guards directed traffic while students made their way to school each morning. This was of particular concern in Mechanicville, because most students had to cross a four-lane state highway that ran through the center of the city to reach School 1 and the high school. Seen here are, from left to right, police officer Warren MacFarren, Margaret Foster, unidentified, and Lucy Mellon.

The recreation fields behind Mechanicville High School were in such poor condition that some schools refused to schedule football games there. Longtime football coach Ted Weigle took out an option on this piece of farmland and, along with the local Rotary Club, helped organize a community effort that led to the purchase of the property in 1946. (MDPL.)

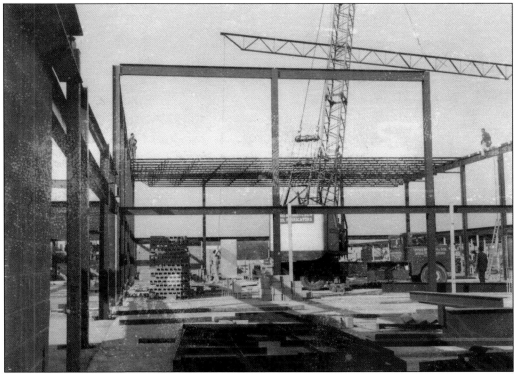

Work began on a new high school in 1962, and the building opened in 1965. A middle school annex was added in the 1980s, and a new gymnasium, classrooms, and athletic fields were completed in 2002. In 2003, the new elementary school opened on adjacent property that was previously unused. (MDPL.)

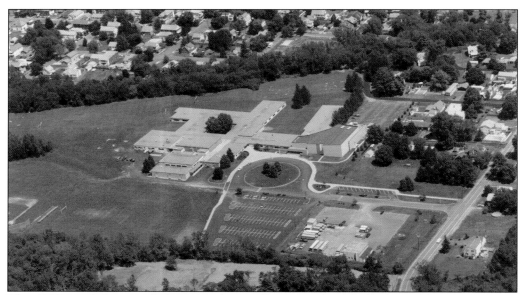

This 1998 aerial photograph shows Mechanicville High School (left), the middle school (right), athletic facilities, and the bus garage in the forefront. With the opening of the elementary school in 2003, the Mechanicville school system had relocated all of its facilities to this location in the town of Halfmoon. (Courtesy of Joseph Micklas.)

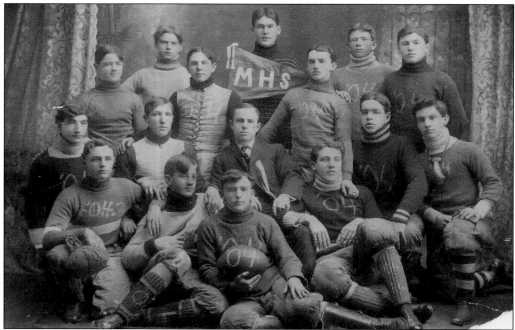

According to the *Saturday Mercury*, Mechanicville's first football game occurred in 1897, which it won 8-0 over Stillwater. They then lost "by a small score" to Waterford. The 11-man team included Principal Lewis Wells. By 1904, the roster had been expanded, but it is not known if the new principal, George Martin, still anchored the line. Note the player on the front left holding primitive headgear and his teammate on the far right with a nose guard hanging from his neck.

"Barton The Koal Man and His Dog Kokoal" were baseball fans, at least judging from the flyer on the right, advertising games between Mechanicville and Stillwater. It was not unusual for such contests to draw crowds of more than 1,000 fans, who enjoyed both the baseball and the Job Safford Band. Barnstorming teams played exhibition games here in the late 1800s, including the Cuban Colored Giants, who toured the country each year.

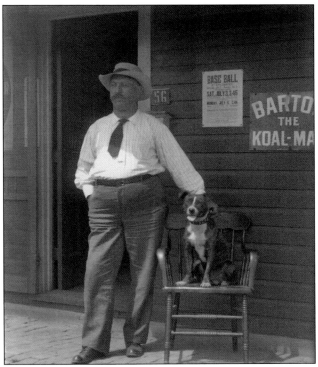

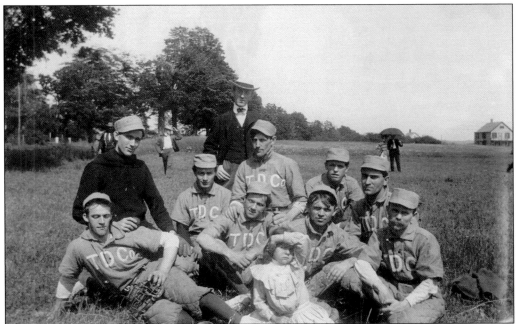

Four local teams competed for fan interest in the early 1900s: the Boston & Maine, the Delaware & Hudson, the Stars, and the Duncan Baseball Club, seen here. Its roster included, in no particular order, Robert Eggleston, C. Vanderbogart, M. Butler, C.H. Davis, H.A. Donnelly, E. Herrington, C. Baker, Doc Clark, ? Collins, and manager J.W. Gibson.

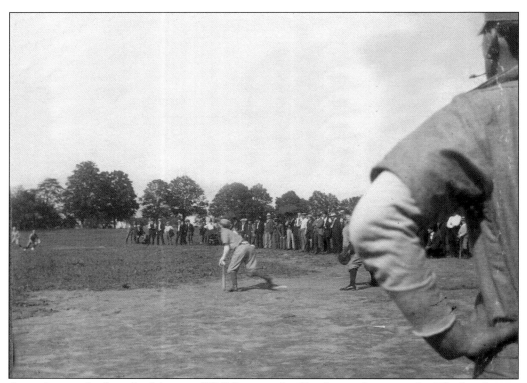

According to the *Saturday Mercury*, "Will Prout at the Plate" rips a liner to right. The local nines competed against each other, but also took on opponents from neighboring towns, attracting the interest of fans and gamblers alike. The press sometimes accused opponents of hiring ringers, and the intensity of one game against Cohoes was such that the visitors released carrier pigeons each inning to keep their fans abreast of the latest score. (MDPL.)

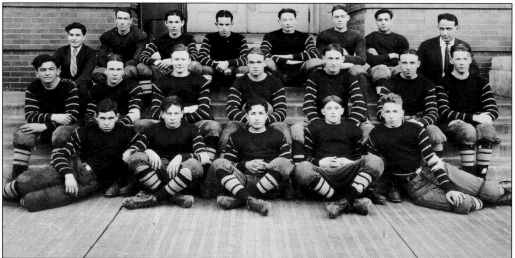

This unidentified team photograph was taken after the new high school was built in 1914, judging from the freshly poured cement sidewalk. Whether or not headgear was provided cannot be determined, but the players look better protected than their predecessors in 1904.

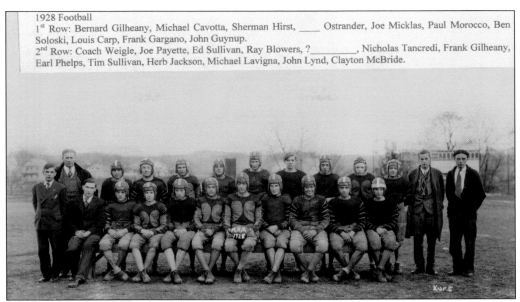

1928 Football
1st Row: Bernard Gilheany, Michael Cavotta, Sherman Hirst, ____ Ostrander, Joe Micklas, Paul Morocco, Ben Soloski, Louis Carp, Frank Gargano, John Guynup.
2nd Row: Coach Weigle, Joe Payette, Ed Sullivan, Ray Blowers, ?_____, Nicholas Tancredi, Frank Gilheany, Earl Phelps, Tim Sullivan, Herb Jackson, Michael Lavigna, John Lynd, Clayton McBride.

Developing high school sports required two things: keeping students enrolled long enough to build teams, and coaches who could build a tradition, attracting younger students. Those factors came together with the arrival of coach Ted Weigle in 1928. He is seen here with his first football team. On this team, Michael "Doc" Cavotta practiced dentistry here into the 1980s after lettering in football at Syracuse University, and his teammate Nicholas Tancredi, a local businessman, played football at Notre Dame. (MDPL.)

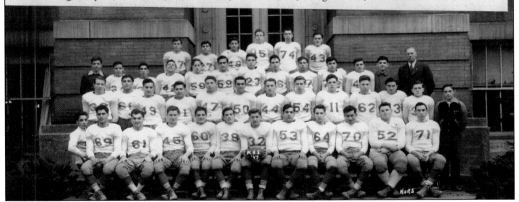

1943 Football
1st Row: Jim Luke, Anthony Anatriello, Nick Perrotta, Don Aldrich, Ed Bochette, Francis Coleman, Val Gaida, Don Gooley, Mike Luke, Anthony Federico, George Hoover, Ed Hinchey.
2nd Row: Jack Dailey, Anthony Lembo, Sal Cononica, Mike D'Amico, Ken Medina, George Dunbar, Weezer Hover, Ed O'Brien, "Ed" Kelly, Bernie McNeil, Pup Daley, Badger Page, Nick Perasky.
3rd Row: Mike Martone, Peter Conners, Sam Angoline, John Valetta, Joe Pender, Victor Bruno, Robert Howland, Ed McGowan, Armond Demicci, Mike Zurlo, Vincent Forino, Rocky Camerato, Coach Weigle.
4th Row: Roger Hayner, Sal Cimino, Pete Clements, Art Serverance, George Downs, Jim Sullivan.

Mechanicville fielded its only undefeated football team in 1943. A number of qualifying factors contributed to the unblemished record, including some schools dropping football during World War II. Additionally, other schools refused to play at Mechanicville's home field, accurately referred to as "a rock pile" by the local newspaper. This situation motivated coach Ted Weigle to enlist local support to purchase land and build new athletic fields in 1946. (MDPL.)

1952 Football
1st Row: John DeVito, Dick Pregent, Augie Almela, Bob Lucas, Bruce Miller, Bob Tassi, Lou Grimaldi, Alan Offenbecker, Pete Hanna, Frank Cocozzo, Anthony Cocozzo.
2nd Row: Art VanDetta, Dan Nolan, Dom Parente, Carl Cuilla, Hooker Forino, Joe Cocozzo, Tom Colosi, Pat Fusco, Lu Verdile.
3rd Row: Ted Levigna, Bob Smith, Larry Whelan, Mike Iacobelli, Bill Henningson, Arthur "Bud" Burgoyne, Lou Bochette. 4th Row: Mert Anatriello, Coach Kalbaugh, Eugene Lynch, Jack Tinney, Tom Petronis, Ted D'Aloia, Coach Weigle, Mike Walsh, John Ponzillo.

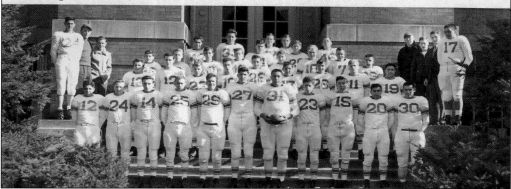

The 1952 football team was led by basketball "Whiz Kids" Robert Tassi, Lou Grimaldi, and Daniel Nolan. During the Draper game, the team experienced a first when three brothers, Anthony, Francis, and Joseph Cocozzo played together. Anthony, who earned Little All-American honors playing at Union College, later became the only MHS graduate appointed superintendent of schools, a position he held from 1976 until 1991. (MDPL.)

1946-47 Basketball
1st Row: Anthony Petta, Paul Bochette, John Henderson, Joe Delano, Leo Fiacco, Don Hinchey, Joe McGuire, John Petta, Ed Ronda, Ray Waldron, Frank Rubino.
2nd Row: Phil Palmer, Rich Bango, Phil Zullo, Jack Sykes, Ernie Decend, Frank Malik, John Purple, Ken Anatriello, Tom Kelly, Phil Falco, Ernie Izzo, Orlando DeVito, Pat DeVito.
3rd Row: Matt Anatriello, Coach Weigle

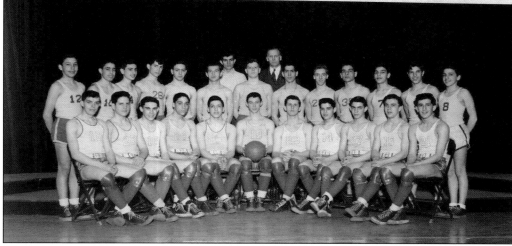

In 1946–1947, Ted Weigle's last year as a basketball coach, he led both the varsity and junior varsity teams. The reins were turned over to a former student, William Kalbaugh, who coached the legendary "Whiz Kids" and later enjoyed a successful coaching career at Rensselaer Polytechnic Institute. (MDPL.)

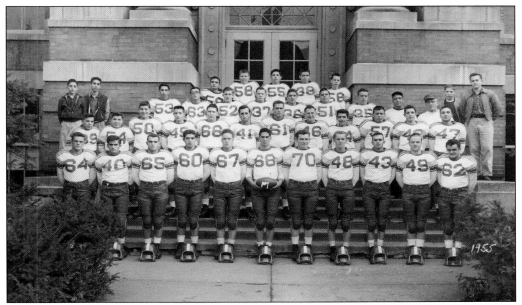

Ted Weigle last coached football in 1955, with a roster almost twice the size of his first team, in 1928. Assistant coach Sam Izzo succeeded Weigle, who continued to work with the track and cross-country teams into the 1960s. In 1966, the board of education named the football field in his honor. (MDPL.)

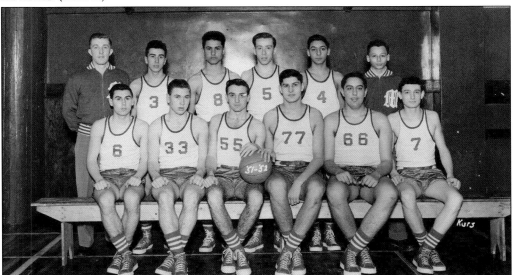

In 1951–1952 and 1952–1953, the Mechanicville High School "Whiz Kids" basketball team achieved legendary status in upstate New York basketball circles, winning 37 of 38 games, with their sole loss by one point. Because of the small gymnasium at the high school, the team played its games at St. Paul's School. They developed such a strong following that people waited hours in line to get tickets, only to be denied because there were not enough seats. The team included, from left to right (first row) Frank Cocozzo, John McNeil, Augustine Almela, Robert Tassi, Louis Grimaldi, and Daniel Nolan; (second row) coach William Kalbaugh, Joseph Palella, Pasquale Capeci, Richard Pregent, Pasquale Palmer, and Anthony Mignacci. (MDPL.)

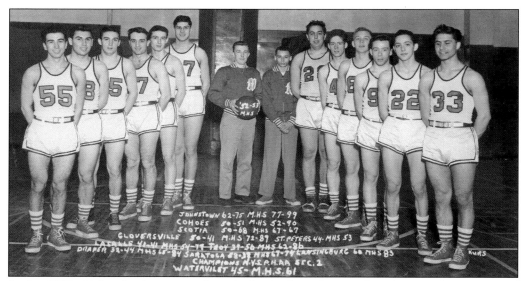

In the 1950s, high schools competed on the basis of proximity rather than on the criterion of size, thus giving Mechanicville's triumphs a David versus Goliath quality since almost all its opponents represented much larger communities. In 1952–1953, the returning players from the previous page were joined by Charles Pascarella (third from left), Leroy Offenbacher (fifth from right), Robert Lucas (fourth from right), and ? Costanzo (second from right). Augustine Almela and Lou Grimaldi became cocaptains at St. Lawrence University, Robert Tassi starred at Colgate, and Daniel Nolan, following an All-American football career at Lehigh, earned a place on the rosters of the Pittsburgh Steelers and the Washington Redskins before becoming a Catholic priest. (MDPL.)

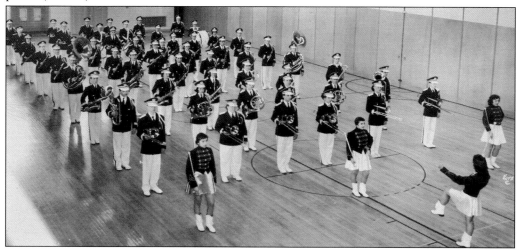

The Whiz Kids' success built support for upgrading the district's facilities, leading to the public endorsement of funding for a classroom addition and a so-called "million dollar gymnasium," completed in 1954. With its seating capacity of more than 2,500 making it one of the largest high school arenas in the capital district, Mechanicville began hosting sectional games that drew large crowds, whose admission fees and expenditures at local restaurants certainly ended up paying for the gym. The facility also permitted the development of other programs, like the marching band, seen here practicing in the gym. (Courtesy of John Caruso.)

Sparse records make it difficult to document the history of women's athletics, which were victim to budget cutbacks during the Depression that were not restored until the 1960s. The 1926–1927 senior girls' basketball team included, from left to right, Olive Smith, Catherine Ryan, Mary Vacarella, Mary Hunt, Isabelle Egan, Mary Roddy, and two unidentified. Mary Vacarella Cavotta passed away in 1912 at the age of 101. (MDPL.)

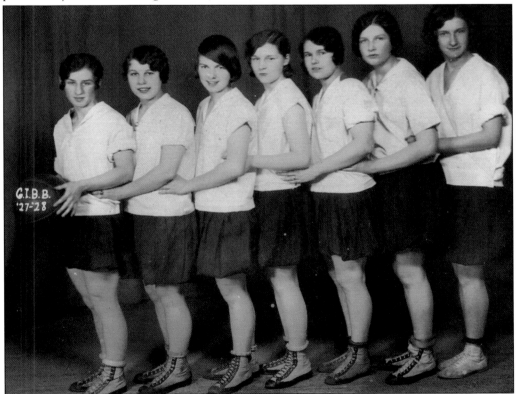

The 1927–1928 girls' intermediate basketball team included, from left to right, Isabelle Egan, Anna Moore, Emily George, May Gaillard, Martha Fisher, Catherine O'Brien, and Statia Lilac. Despite the long hiatus in girls' sports, the 1988 soccer team won the New York State Class C championship, and recent teams have advanced deep into intersectional competition. The girls' softball team has established an envious record unmatched by any team, winning the New York State Class C championship five times. (MDPL.)

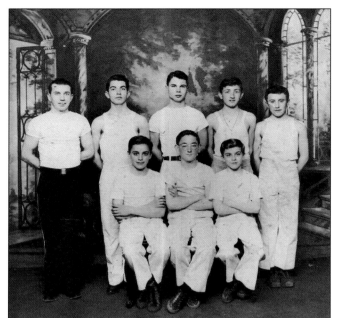

One boys' sport that has disappeared is tumbling, an early form of acrobatics popular in the 1930s. This team from that era included, from left to right, (first row) Robert Mockrish, Victor Alvarez, and unidentified; (second row) coach Harold Sheehan, John Gilhooley, Arnold Westcott, Anthony Luciano, and George Marinello.

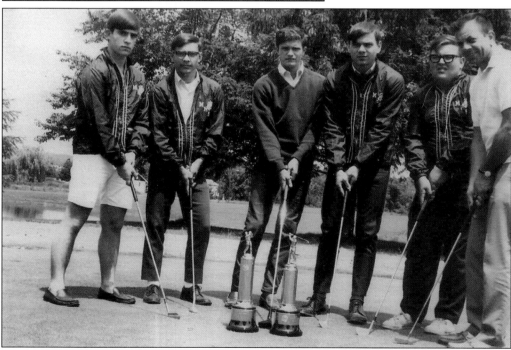

Mechanicville has a tradition of success in golf, led for many years by coach Michael Martone. This team included, from left to right, Arthur Manso, Joseph Laurenzo, Stephen Sgambati, William Malo, Francis Beninati, and coach Martone, who also successfully coached the basketball team after starring as a basketball player at St. Bonaventure University. Martone became a leader in section II athletics, coordinating many sectional basketball tournaments, a number of which were played in Mechanicville, from 1954 through the 1980s. (Courtesy of John Caruso.)

Six

IT TAKES A VILLAGE
TO BUILD A CITY

Mechanicville was transformed by the rerouting of the Champlain Canal into the Hudson River, which opened development along what became Central Avenue. Irish immigrants built the original canal in the 1820s, while Italian immigrants rebuilt it from 1910 to 1912. Many of the Italian laborers attracted to the project stayed in the area after its completion, joining compatriots who manned the local paper mill, brickyards, and railroads to form the largest ethnic group in the community.

New York's smallest city is a study in contrasts. Most residents could recognize photographs taken a century ago, as much of the cityscape remains unchanged. Confined to an area of less than one square mile, Mechanicville's boundaries have not changed since 1911. Most of it was completed prior to 1920, particularly in the residential north end, on South Main Street, and on the west side, where changes have been largely cosmetic. However, the city's commercial and industrial infrastructure underwent drastic changes between World War II and 1985, and is unrecognizable in some areas. Contributing factors included the almost complete disappearance of the city's industries, a series of fires typical in older industrial cities, and attempts to modernize Mechanicville's commercial core through urban renewal.

All of these factors combined to eliminate entire sections of the community, so that anyone born after 1980 might as well be looking at the dark side of the moon when they review some of the photographs reprinted here. In that sense, Mechanicville has undergone a transformation typical of many postindustrial communities in the Northeast. Yet, partly because of its small size, and partly as a result of the sense of connectedness that many of the families who came here as immigrants more than century ago still feel, the city has been able to avoid being abandoned, as many larger communities have been.

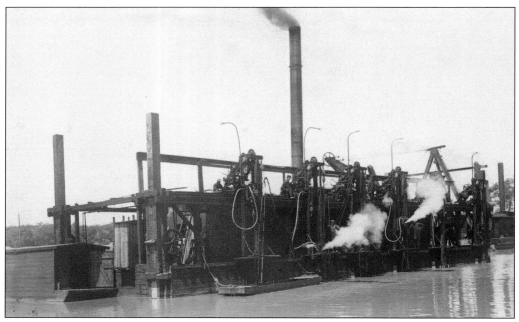

A transformed canal capable of carrying deep-drafted barges required extensive dredging of the Hudson River. This Marion Dipper dredge was built on-site by the Shanley-Morrissey Company, which was simultaneously working on the construction of the Erie, Oswego, and Champlain Canals.

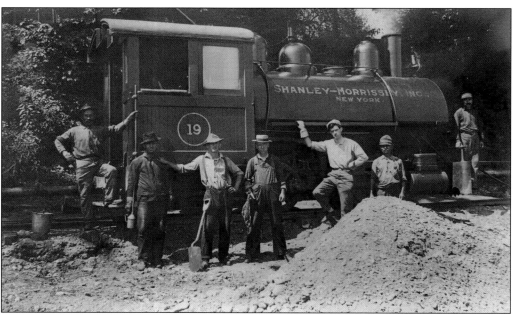

Canal building in the 1900s was capital-intensive, requiring the building of small-scale railroads, dredges, excavators, concrete mixers, steam pumps, and locomotives—all of which were of use only at specific job sites and not easily moved elsewhere.

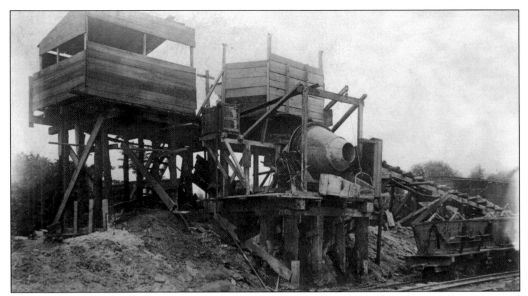

The scale of cement and concrete work needed to build the 15-to-20-foot-deep walls is captured in this photograph of a cement mixer used to fill trainloads of cars. All such infrastructure had to be replicated over and over again as lock-building moved farther up the river, adding to the financial risks that companies like Shanley-Morrissey had to assume.

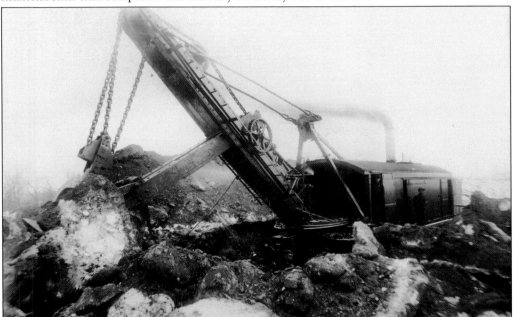

This is one of the Marion Steam Shovels used to build Locks 2, 3, and 4 in Mechanicville and Stillwater. The task was further complicated because preexisting hydropower dams at the lock sites required careful coordination between the construction company, the Hudson River Electric Company, and Westvaco, which intended to continue operating while the locks were being built. This machine is large enough to imagine it being used in the building of the Panama Canal, which was also underway at that time.

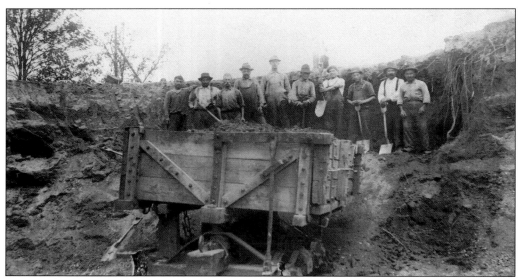

Despite the heavy outlay in capital, the new canal, like its predecessor, required the pick-and-shovel labor of hundreds of immigrants, who were often in danger of being crushed in the frequent landslides that marked the work. As it happened, the Shanley-Morrissey Company overextended itself by engaging in three simultaneous canal projects, and the *New York Times* reported that all of its local equipment and property were to be auctioned off on December 10, 1912, after the company filed for bankruptcy.

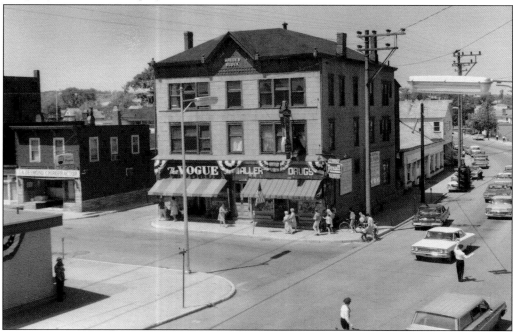

Looking northwest across Central Avenue after the old canal bed had been paved over, this corner of Park Avenue was the busiest intersection in the city. Waller Drugs had the only Western Union outlet in the city, which kept families abreast of news of their sons serving in the armed forces in the 1940s and 1950s.

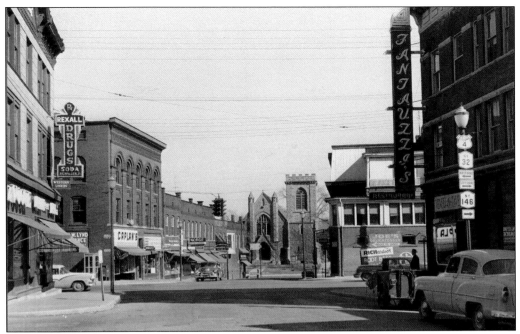

This photograph looks east on Park Avenue in the late 1950s, showing, from left to right, the Mead Building, St. Luke's Episcopal Church, the Flanigan Block, and Fantauzzi's Restaurant. This was, and still is, the major intersection in Mechanicville, although three of the four corners were transformed by fire and urban renewal. (MDPL.)

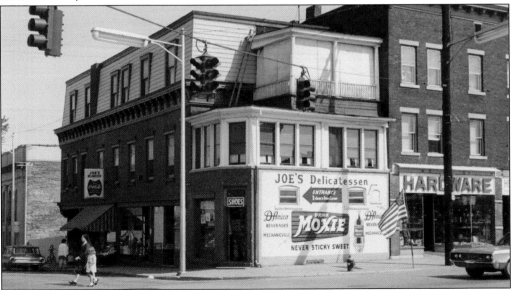

The southeast corner of Park and Central Avenues was dominated by the multiuse Flanigan Block, combining street-level businesses and upper-floor residential units. About 50 years before this photograph was taken, Joe Dodd's carriage and sleigh shop had anchored the site adjacent to the lift bridge over the canal. Today, the building looks much as it does here, although Ida Cohen's shoe store, Baker Hardware, and Joe's Delicatessen have been replaced by new businesses.

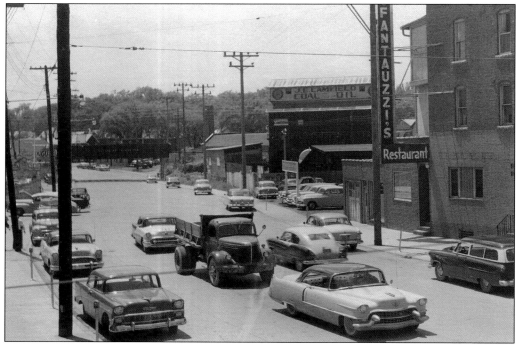

This photograph looks south down Central Avenue, which follows the same path as the original canal. The popular Fantauzzi's Restaurant, patronized by travelers and local customers, was destroyed by fire during a winter thunder snowstorm on January 1, 1961. The coal sheds in the background were taken down in the early 1970s. (MDPL.)

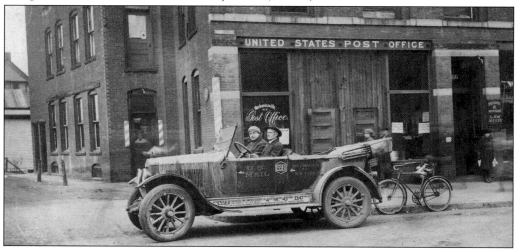

This World War I–era photograph shows the dreaded "s," as in "Mechanicsville," on the post office window. The "s" began appearing on postal cancellations of outgoing mail in 1846, although no Mechanicville legal entity authorized the extraneous letter. Postal covers dating to the mail service's earliest days clearly show Mechanicville, not Mechanicsville, as the correct address. However, the erroneous usage persisted for so long that even some older local residents are convinced that they grew up in Mechanicsville. With neither explanation nor apology, the postal service ceased pluralizing the city's name in 1921.

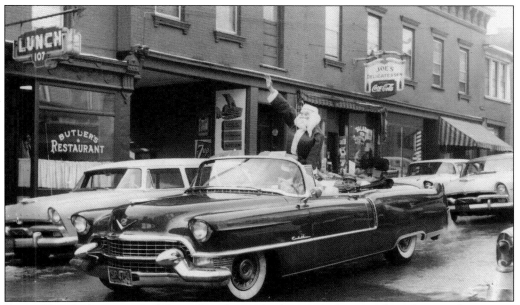

Santa Claus had to use a Cadillac rather than a sleigh to make his rounds in this snowless winter in the late 1950s. Joe's Delicatessen, run by the DiDimenico family for two generations, was a mainstay on Park Avenue into the 1980s. Butler's Restaurant, abutting the State Bank of Albany (not shown), was torn down to make way for bank expansion in the early 1970s. (MDPL.)

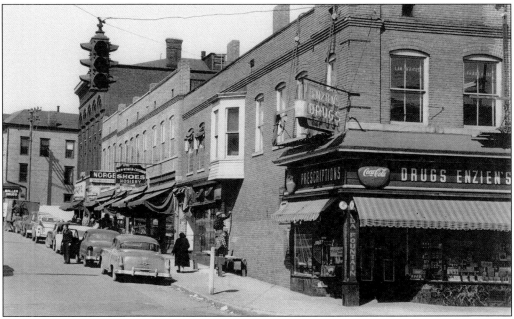

Park Avenue between Main Street and Central Avenue was an important part of Mechanicville's commercial district from the 1940s through the 1960s. Two of the first three buildings on the right remain, with the drugstore having been converted into apartments and the old appliance and shoe stores occupied by piano and antique dealers. The Mead Building, at the end of the block, was torn down in the 1970s, and the site now houses a one-story restaurant. (MDPL.)

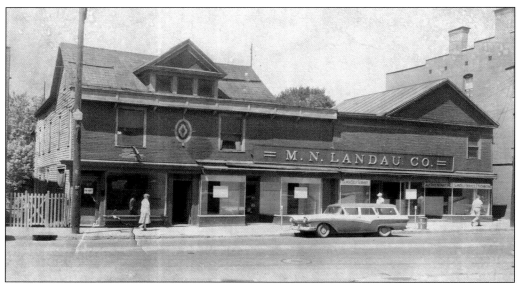

M.N. Landau ran a "five cents to a dollar" store on North Main Street from the 1920s through the 1950s. Apparently, the name was chosen to distinguish the business from the five-and-dime stores that were popular in that era. The building was torn down to make way for the municipal parking lot. (MDPL.)

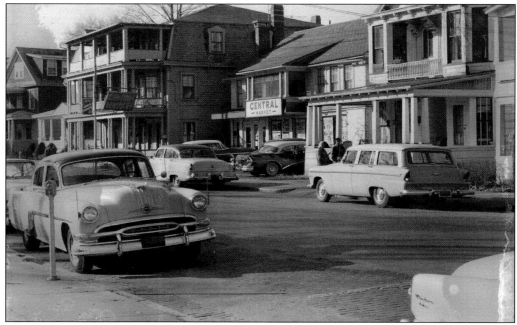

Central Market, the predecessor of today's supermarket giant, Price Chopper, got its humble beginnings locally, on South Main Street, in a building most recently used to store golf carts. The business first relocated to North Central Avenue before opening the current Price Chopper Plaza in the early 1990s. (MDPL.)

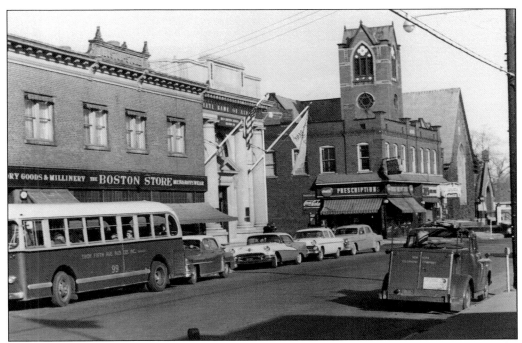

This view looks north across South Main Street in the 1950s, showing the Boston Store, a popular department store in a space now used as a bank parking lot. Passengers could get regular bus service to Troy every half hour at this site until the late 1960s, when service was severely curtailed. Today, except for minimal service on weekday mornings, public transportation to surrounding communities is virtually nonexistent. (MDPL.)

Some of Mechanicville's downtown businesses on the west side of North Main Street included, from left to right, the Packer Block, the State Theater, Joyce's Log Cabin, and a multilevel apartment dwelling. None of these buildings remain. Joyce's was the last to go, in the early 2000s. The Mechanicville Fire Station and an empty lot now occupy these sites. (MDPL.)

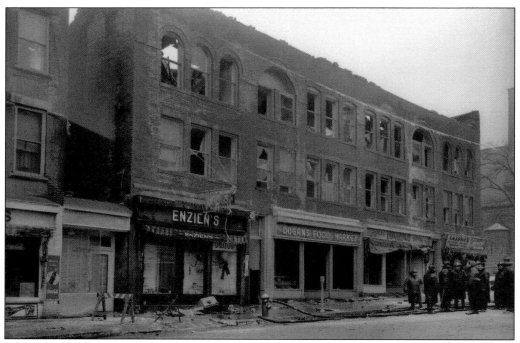

This large block, housing businesses and apartments on North Main and William Streets, was typical of multiuse urban architecture in the first half of the 1900s, when most of Mechanicville's downtown was built. The block was destroyed by fire in 1948. Enzien's Drugs and Dugan's Food Market continued operating for a number of years, relocating one block south on North Main Street. A gas station is currently located here. (MDPL.)

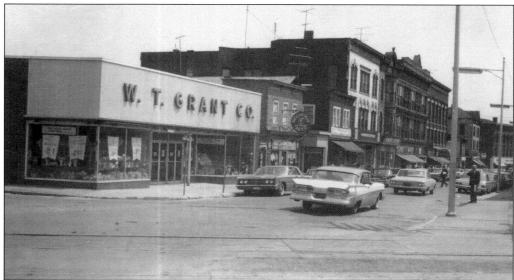

W.T. Grant Co. operated at 220 Park Avenue in the 1940s and early 1950s before moving to 232 Park Avenue, seen here, after the Hotel Estelle Rita was torn down in 1954. In the late 1960s, it became the anchor store of the Mechanicville Plaza. The store closed when W.T. Grant Co. went bankrupt in 1975.

The W.B. Neilson Hose Company is the only one of the five original firehouses erected between 1885 and 1905 that remains standing. The building has most recently been used as a preschool center. Because long freight trains entering the local yards cut off sections of Mechanicville for lengthy periods, there were five firehouses situated in different neighborhoods.

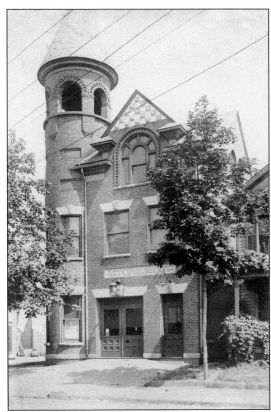

The C.M. Fort Store was grafted onto the Revolutionary War–era cobblestone house below on Mabbett and North Main Streets. Despite widespread public opposition, the structure was torn down by urban renewal to widen the street and expand a church parking lot. The move outraged *New York Times* architecture critic Ada Louise Huxtable, who blasted the removal of the Greek Revival structure, which she judged to be "about the only historical and architectural ornament in the area."

"If only the walls could talk," many people said over the years when referring to Joyce's Log Cabin, Mechanicville's iconic restaurant, which entertained a cast of characters right out of Damon Runyon while also serving as the scene of weddings, class reunions, and other social events. An outbuilding behind the restaurant reportedly catered to those who might have liked to place a wager now and then. Joyce's Log Cabin was originally known as Joyce's Log Tavern. (MPDL.)

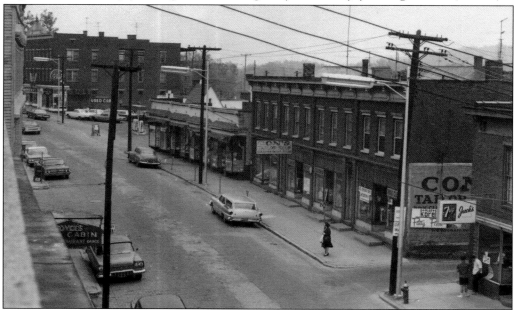

North Main Street in the 1950s included Jack's (right), a popular teen hangout. All of these brick units were torn down by urban renewal in the 1960s except for the structure on the far left. The original buildings were replaced by the Kennedy apartment complex. (MPDL.)

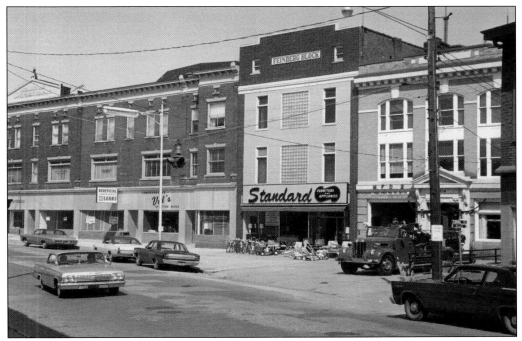

All of the structures seen here on North Main Street in the 1950s remain more or less the same, with changes of business names. The Municipal Building on the far right has since converted the D.E. La Dow Hose Company quarters into offices.

This classic "club car" diner operated at the wye formed by the intersection of Mabbett, Railroad, and School Streets through much of the first half of the 1900s. The structure was removed when the area was reconfigured under urban renewal, which also turned School Street over to private developers. (MPDL.)

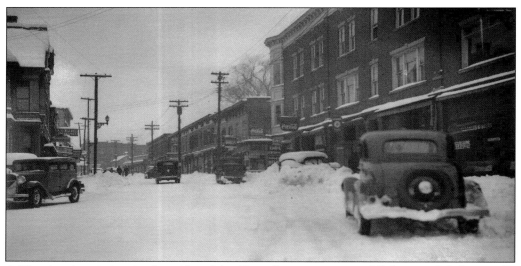

Adding insult to injury in the midst of the Great Depression, snow fell faster on Mechanicville in 1933 than the stock market had in 1929. The building in the right forefront remains largely intact, except for the portion with the bay windows, which burned down in the early 2000s. The obscured structure in the upper left still stands as well, but other than that, all of the buildings seen here on both sides of the street have been removed.

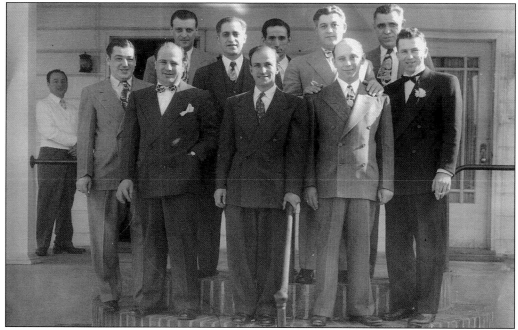

Attendees at a wedding at the Schuyler House, which the *New York Times* described as a "well known restaurant," included, from left to right, (first row) Joseph D'Aloia, Ralph DeMartino, Alfred Carroll, and Bernard Daily; (second row) Angelo Sylvester, Guido Tuccillo, Charles Pettograsso, John Torocello, Nicholas Cavotta, and Anthony Delano. The waiter on the left was Joseph Crevelone. The restaurant was destroyed by fire on January 10, 1949. (Courtesy of Anthony Sylvester.)

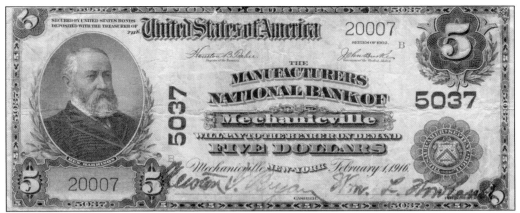

The phrase "hometown banking" resonated more directly in 1916, when the officers at one's bank were also one's neighbors. Notes backed by the federal government were issued by banks like the Manufacturers Bank between 1863 and 1934. When this note was issued, Newton V. Bryan, whose signature is on the left, lived on South Main Street, and William L. Howland, whose signature is on the right, lived on South Second Street. (Courtesy of Joseph Micklas.)

On January 23, 1904, Howland and Bryan told the *New York Times* that "the run was absurd" when shop workers suddenly withdrew their deposits. They weathered that turmoil by having $50,000 in cash delivered the next day, restoring confidence. However, like other institutions, they faced a more severe run following the stock market crash of 1929, when panicked depositors demanded their money. Resorting to the same strategy employed in 1904, the officers made a public display of a Brinks truck delivering bags of money to the bank. (Courtesy of James Salmon.)

This widely distributed photograph of the cashier displaying the bags of cash was intended to calm nerves. Unfortunately, what worked in 1904 did not succeed this time. Both of Mechanicville's banks collapsed, leaving the city without one for two years. (Courtesy of James Salmon.)

Mechanicville, located on the main route for travelers going to Saratoga and points north, presented a bottleneck, particularly when freight trains caused long delays on Route 67. State engineers proposed building a Saratoga arterial overpass above the railroad and through the city's largely immigrant north end in 1946. Finally, 30 years later, a scaled-down version incorporating only an overpass at Saratoga Avenue was completed, and north end housing remained untouched.

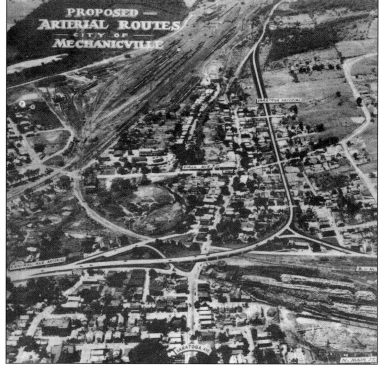

Seven

THE WAY WE WERE NOT SO LONG AGO

Mill retiree Stephen Dennis recently recalled how he anticipated the closing of Westvaco long before his peers who were later caught off guard. He described a meeting in which company president David Luke, a former resident of Mechanicville, complimented employees for taking advantage of training programs the company offered. But, while many others missed it, Dennis detected a note of frustration in Luke's tone regarding the lack of employee enthusiasm to move up the corporate ladder, if it meant they had to leave the community. As he well knew, too many people were comfortable walking to work, socializing with friends and family, and raising children in the intimate confines of the Mechanicville community.

Most of Mechanicville's population consists of immigrant stock, whether it be Irish, Italian, Russian, or Lithuanian. Even those already considered American when they came here from Holyoke, Billerica, or other industrial centers arrived in groups. The factories, businesses, and homes here all provided the infrastructure necessary to create a city. But beyond that, Mechanicville was able to develop a strong, close-knit identity and sense of place that are unusual, even for small communities. This was proven true in 1998, when hundreds of people came to help clean up the destruction left in the wake of the tornadoes that hit here. Visitors often asked local residents, "Is everyone in Mechanicville related to each other?" The answer, of course, is no; but it might as well be yes.

The issue that has arisen in Mechanicville's postindustrial landscape is: can such a communal way of life be sustained when its economic underpinnings disappear? That question remains for future generations to answer. Hopefully, they will take some time to reflect back on the city's history to see what made it the way it is, and appreciate the qualities that gave Mechanicville such a unique community character.

Musical director Ray Heindorf (center), with 18 Academy Award nominations in his career, was feted in his hometown in 1953. The Mechanicville High School graduate started out playing musical accompaniment during silent movies at the Star Theater on North Main Street. When his request for a raise was turned down, he left for New York, and eventually went to Hollywood. Heindorf won Oscars for *Yankee Doodle Dandy* in 1943, *You're in the Army* in 1944, and *The Music Man* in 1953. He is flanked by Mechanicville mayor Thomas Ryan (left) and Fred Amodeo. (MDPL.)

Mechanicville observed the centennial of Col. Elmer Ellsworth's birth with a three-day celebration in May 1937. This parade, held on May 21, included a large contingent of New York City firemen, who were given three days of paid leave to attend the festivities by New York City mayor Fiorello LaGuardia. Colonel Ellsworth had recruited Fire Zouaves from the ranks of New York City's volunteer firemen in 1861. (Courtesy of Joseph Waldron.)

John Ennello, who started as a patrolman in 1915, became the chief of police in 1922, with the specific task of controlling the "black hand" of organized crime, which held sway. According to the quarterly *Police Reporter*, Ennello's "knowledge of . . . the character of the Italian people . . . enabled them to realize that the law was their friend and not a bugaboo to be fled by innocent and guilty alike." His evenhanded command of the situation is credited with ridding the community of organized crime in the 1920s. (Courtesy of Joseph Waldron.)

Msgr. John Nolan (below, far right) is seen here following a private audience with Pope Pius XII (center) in 1958. Nolan served as secretary general and president of the Pontifical Mission for Palestine from 1967 through 1987. His opinions were often solicited by the national news media because of his familiarity with Palestinian issues. (Courtesy of John Caruso.)

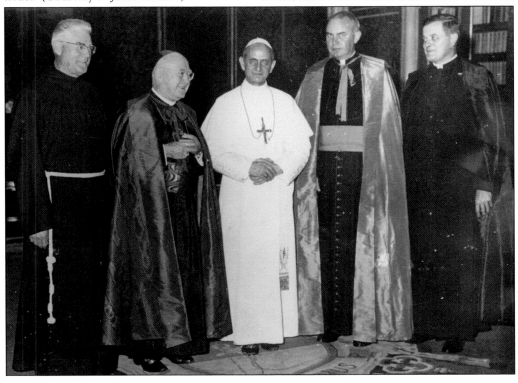

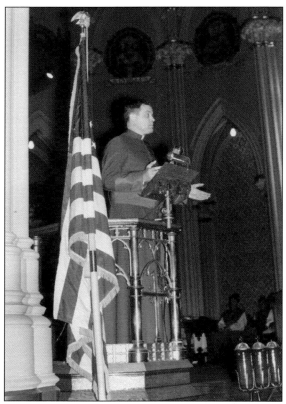

Msgr. John Nolan, seen here preaching at St. Paul's School, often returned home to celebrate mass. After serving as the secretary general and president of the Pontifical Mission for Palestine from 1967 through 1987, he was appointed bishop of the Military Ordinariate in 1988, and served for four years in Europe as the Episcopal vicar for American military personnel and their families. (Courtesy of John Caruso.)

Fr. Serafino Aurigemma, OSA, is seen below with parish altar boys around 1930. He first arrived in Mechanicville in 1906 as an Augustinian missionary to serve the Italian immigrant population. Following assignments elsewhere, he returned in 1919, establishing the ethnic Italian Church of the Assumption parish. When he was elected to the board of education in the 1940s, he was believed to be the only Catholic priest in America to hold such a position. He served continuously as pastor until his death in 1971. (MDPL.)

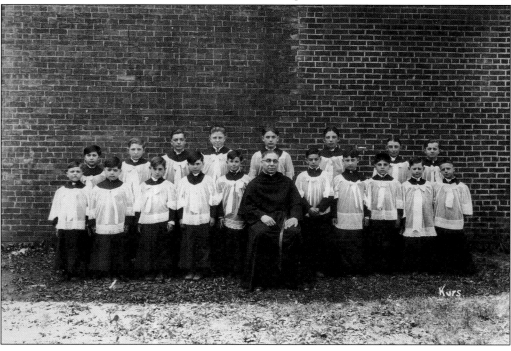

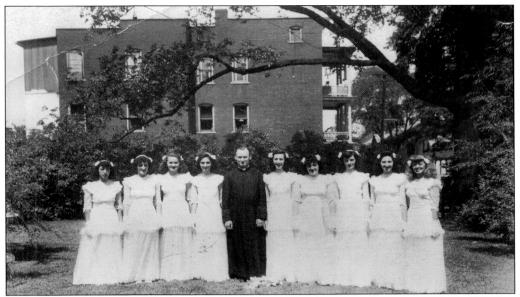

These Assumption parish girls are preparing to process with a painting of the Blessed Mother through the streets while celebrating the August 15th Feast of the Assumption. They are, from left to right, Philomena Guillianelle, Anna Luciano, Virginia Valentino, Angela Farina, an unidentified priest, Millie Tironi, Carmina Clements, Josephine Arnold, Anna Dantino, and Rose Zappone.

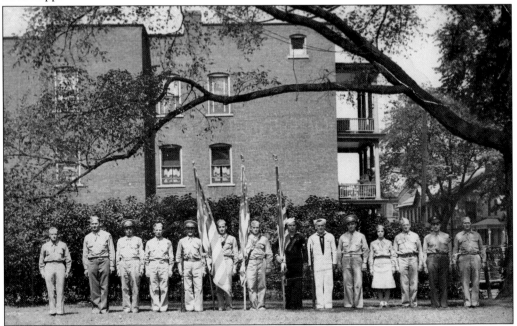

Italian Americans who served in World War II prepare to march in the Assumption Day parade in 1946. The war was a watershed moment for the Italian immigrant community in terms of its acculturation and acceptance in America. The large numbers serving in the war led to the organization of the Peters Purcell Italian American War Veterans.

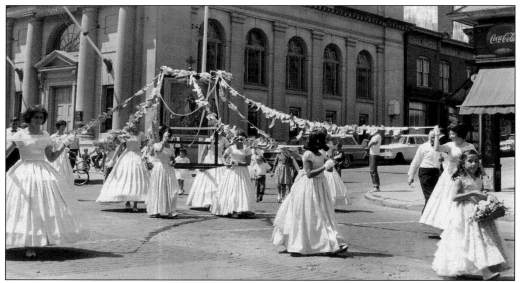

Say "the 15th" to anyone familiar with Mechanicville, and they will immediately recognize the reference to the three-day celebration of the Feast of the Assumption, first organized by Italian immigrants in 1903. The celebration includes a procession like the one seen here in the 1950s, with a painting of the Virgin Mary bedecked with streamers holding dollar bills, which are pinned on by residents during stops along the way, signifying their *votte* to Mary. The festivities, which conclude with spectacular fireworks displays produced by the Alonzo family, continue today, although the events have been scaled back to a single day.

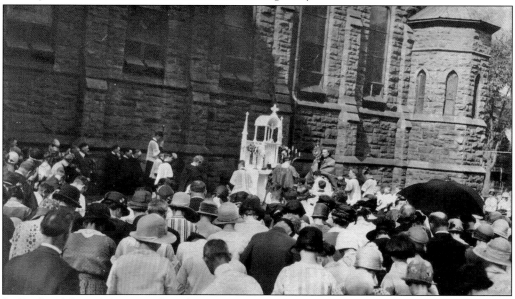

St. Paul's celebrated this special outdoor Exposition of the Blessed Sacrament in the 1940s. Founded in 1852, St. Paul's parish conducted services in the 1852 church on William Street. The rapid expansion of the Catholic community in the early 1900s led to the building of this much larger structure on North Main Street, completed in 1916. Three years later, the Italian ethnic parish reopened the original church, which served that community until it was closed in 2008.

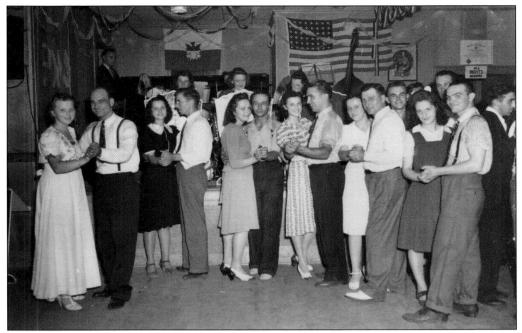

Members of the St. John's Polish Society pause during a dance in 1940. Polish-speaking immigrants, many of them Lithuanians residing in Riverside, organized an ethnic society during World War I. Polish immigration declined quickly after the war, and the group diminished in size, eventually disbanding after World War II.

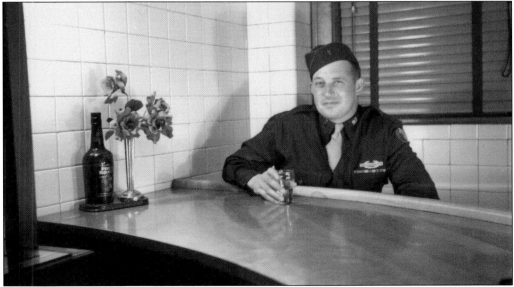

Between 1942 and 1945, Eugene Siciliano photographed more than 2,000 local servicemen home on leave at his bar on Warsaw Avenue. Each of these men, like William Brenn, seen here, posed with a vase of flowers and a bottle of Four Roses on the bar. Michael Sullivan salvaged and copied the collection for the Mechanicville Library files. The original photographs hang in Costanzo's Restaurant on the Waterford Road.

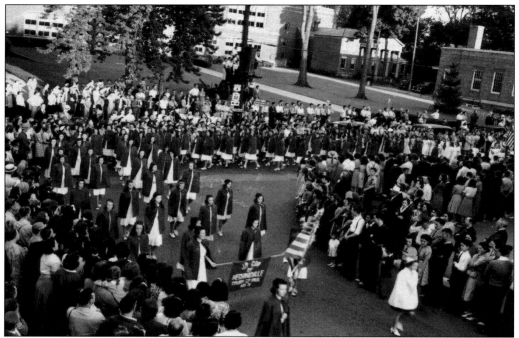

The Junior Catholic Daughters local contingent marches up Main Street entering Park Avenue in the large parade celebrating Flag Day in 1940. Young boys behind the signs for Routes 4 and 32 are standing atop a World War I artillery piece that was reclaimed in 1942 as part of a scrap metal drive.

No one recorded the date of this photograph, but it is noted that the occasion marked the arrival of the first airplane in Mechanicville. Clothing styles and the development of airplanes date it somewhere in the 1920s. Amelia Earhart campaigned in Mechanicville on behalf of Pres. Franklin Roosevelt in 1936, but the fact that she drove her own automobile with her husband as a passenger caused as much comment as if she had landed a plane.

Dow Clute (back center), who enjoyed a lengthy career as a Methodist minister, presided over this children's service around 1920, which included, from left to right, (first row) Irma Caldwell, Pricscilla Hammersley, Geraldine Sipperly, Sarah Downing, and Catherine Cookingham; (second row) Ralph Blair, Homer Peters, Chester McLaughlin, Harold Babcock, Benjamin Rogers, Katherine Hammersley, Dora Isles, Marion Vandenburgh, Charlotte Record, Gertrude ?, and Doris Hicks.

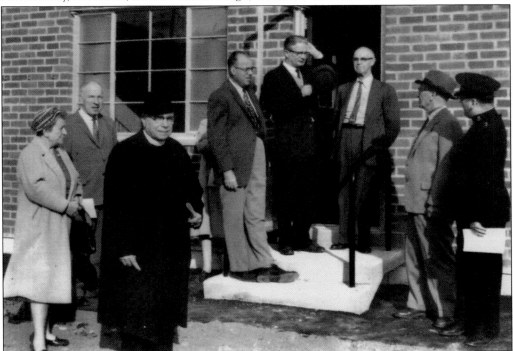

Rufus Hodges (in doorway) talks to Mechanicville mayor Thomas Nolan (to the left of Hodges, holding hat) at the dedication of new public housing units in November 1961. Hodges was the founder of the Mechanicville Housing Authority. In 1953, the *New York Times* reported that Hodges was given the annual award for individual achievement by the National Association of Housing Officials.

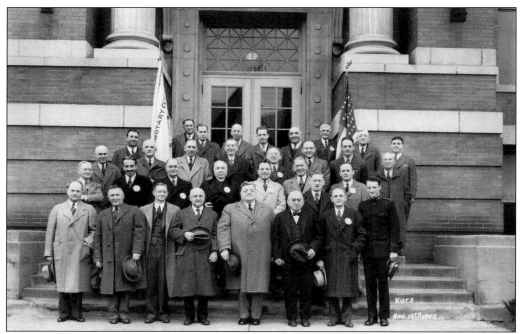

Rotarians, seen here on the steps of the high school, were instrumental in resurrecting local banks during the Depression, as well as organizing the community to expand youth activities and facilities. One of their founders, Mechanicville mayor George Slingerland, rallied area club members to save the Saratoga Battlefield, an effort that resulted in the site becoming part of the National Park Service.

With the nearest hospital facility 15 miles away, Mechanicville residents have depended upon the John H. Ahearn Rescue Squad to transport them to a hospital in medical emergencies since 1955. Originally manned by volunteers, the squad currently employs emergency medical technicians, but the service continues to be provided free of charge. The squad is always on call at local high school football games, as these squad members were throughout the 1960s. They are, from left to right, Eugene Lynch, Michael Rinaldi, Stephen Ponzillo, and Harold Sheehan.

This 1950s-era information card distributed by the rescue squad captures a bit of history. Nine of the ten physicians listed are deceased, and the sole survivor, Dr. Stephan Sgambati, retired in 2013. Dr. Sgambati's son Stephen Jr. has the only practice in town today. The Baptist, Presbyterian, and Episcopal congregations no longer conduct services in Mechanicville. The merger of the Assumption parish with St. Paul's eventually led to the closing of the former's church. The Methodists continue worshipping at the North Main Street church they erected in 1883.

COMPLIMENTS OF

John H. Ahearn Rescue Squad, Inc.

MECHANICVILLE, N. Y.

DOCTORS

Bieringer, Heinze	MO 4-4185
Crissey, G. W.	MO 4-3073
Fantauzzi, Anthony	MO 4-3185
Enzien, John A.	MO 4-3083
Green, George A.	MO 4-3425
Mastrianni, B. F.	MO 4-4711
Mastrianni, F. A.	MO 4-3851
O'Brien, John	MO 4-4085
Purcell, J. R.	MO 4-3421
Sgambati, Stephan	MO 4-5401
Werner, William	MO 4-4015

CLERGYMEN

Presbyterian	MO 4-3084	MO 4-3416
Baptist	MO 4-5204	MO 4-3063
Methodist	MO 4-3554	MO 4-3095
Episcopal		MO 4-4834
St. Paul's R. C.		MO 4-3105
Church of Assumption R. C.		MO 4-3705

For Long Distance Transportation over 50 Miles
Consult our Dispatcher — MO 4-7384

EMERGENCY CALLS
CALL MO 4-7384
WHEN CALL IS AN EMERGENCY CALL ALWAYS GIVE YOUR NAME AND ADDRESS AND STATE NATURE OF EMERGENCY.

TRANSPORTATION
WHEN CALL IS FOR TRANSPORTATION TO OR FROM HOSPITAL WE WOULD LIKE 24 HOURS AHEAD IF POSSIBLE SO WE CAN HAVE OUR MEN AVAILABLE.
CALL MO 4-7384
NO WALKING CASES

Below, couples dance at a Senior Dante festival at the Sons of Italy Hall on Saratoga Avenue in 1940. They are, from left to right, Mary and Dominick Belmonte, an unidentified couple, Josephine and Angelo DeCrescente, an unidentified couple, Louise and Daniel Fasolino, Barbara and Angelo DeVito, and Margaret and Angelo Michele. Barbara DeVito passed away in November 2011 at age 101.

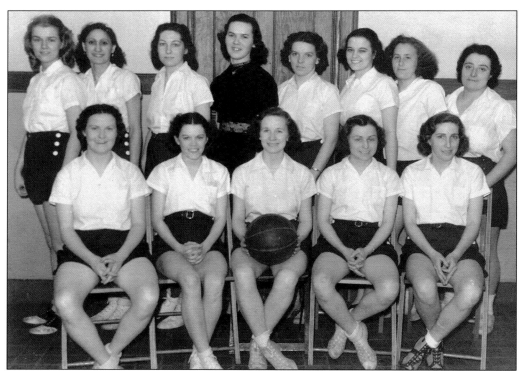

The 1940–1941 Catholic Youth Organization (CYO) women's basketball team, the Blue Streaks, included, from left to right, (first row) Evelyn Waldron, Rita Sullivan, Doris O'Connor, Matilda Richardson, and Madeleine Reilly; (second row) Katherine Nolan, Esther Scott, Eleanor Reilly, coach Sophie Bramski, Dorothy Whitman, Kathleen McCarthy, Betty Tinney, and Anna Caruso.

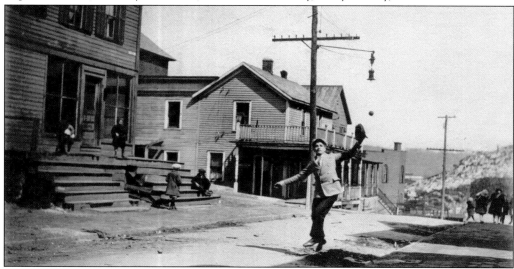

Vincent Fantauzzi leaps to catch the throw from his brother Anthony on Warsaw Avenue in 1926. Large woodpiles of the Westvaco paper mill can be seen in the background. The lack of youth facilities in the crowded immigrant section led residents to organize the North End Improvement Association in the 1930s.

This Sons of Italy picnic on September 25, 1961, included, from left to right, Henry Marmillo, Lorraine Fusco, Michael Zappone, Marilyn Zappone, Paul Reitano, John Fusco, Daniel Fusco, Judy Zappone, and unidentified.

Young would-be pool hustlers cue it up at the Columbia Club on Saratoga Avenue. In the 1940s, the Rotary Club volunteered to help supervise the youths. Many young boys looking to make a few dollars worked as pinsetters at the club's bowling alleys, which hosted leagues every night.

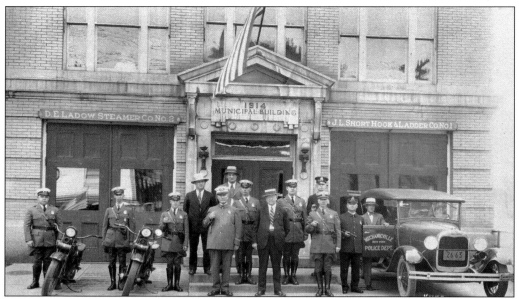

Police chief Michael Ennello (first row, fourth from left) poses with Mechanicville mayor Thomas Tweedy (first row, center, in straw boater) and the Mechanicville Police Department in 1929. Notably, both the J.L. Short and D.E. LaDow fire companies were stationed in the Municipal Building. Today, city commissioners' offices occupy that space.

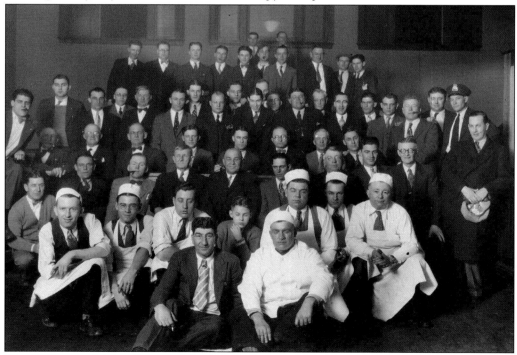

The 1930 annual joint dinner of the D.E. LaDow and J.L. Short fire companies took place at city hall on Saturday, December 27, and was catered by Duffney Brothers. In the very front are longtime fire chief Michael Grimley (left) and Louis Duffney (right).

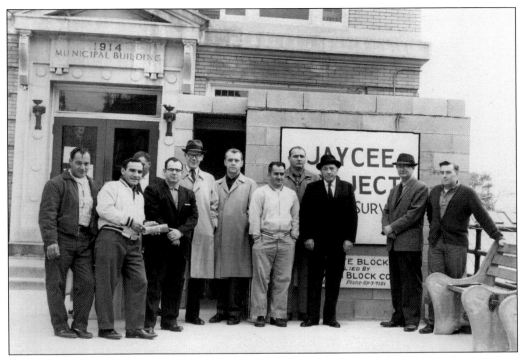

Mayor Thomas Nolan (second from right) poses with the Jaycees in the 1960s, whose project that year was to build a nuclear bomb shelter in front of the municipal building. The primary community shelter was 500 feet south, in Mechanicville High School.

Trapshooting competitions were held by the Mechanicville Game Shooting Association, across the Hudson River in Hemstreet Park, dating back to 1903. They remained part of the annual community calendar until the early 1940s, when this photograph was taken.

Discover Thousands of Local History Books Featuring Millions of Vintage Images

Arcadia Publishing, the leading local history publisher in the United States, is committed to making history accessible and meaningful through publishing books that celebrate and preserve the heritage of America's people and places.

Find more books like this at
www.arcadiapublishing.com

Search for your hometown history, your old stomping grounds, and even your favorite sports team.

Consistent with our mission to preserve history on a local level, this book was printed in South Carolina on American-made paper and manufactured entirely in the United States. Products carrying the accredited Forest Stewardship Council (FSC) label are printed on 100 percent FSC-certified paper.

MADE IN THE USA